RENOIR

The life and work of the artist illustrated with 80 colour plates

ELDA FEZZI

THAMES AND HUDSON

Translated from the Italian by Diana Snell

This edition © 1968 Thames and Hudson, 30–34 Bloomsbury Street, London WC1
Copyright © 1968 by Sadea Editore, Firenze
Reprinted 1979

Printed in Italy

Life

Pierre-Auguste Renoir was born in Limoges on 25 February 1841. In 1845 his family moved to Paris where the father, a tailor, went on making a modest living to support his already large family. Pierre soon showed he was a particularly gifted boy, and he might have studied singing, according to the organist of the parish church of Saint-Roch, Charles Gounod. But Renoir's father much preferred the idea of a solid artisan occupation, and for his son he chose a job as a decorator in the firm of Lévy Frères, porcelain manufacturers in the Rue du Temple. By doing lively imitations of Sèvres shepherds, Louis XV effects, garlands and figures *à la* Boucher, Renoir learnt the use of fluid, delicate colour; and he so stood out from the other decorators that he was able almost immediately to ask for a rise. M. Lévy resolved to put him in the dessert plates department, and give him two centimes for each plate, three for a likeness of Marie-Antoinette.

The ones with the picture of the Queen sold like hot cakes ' thanks to the guillotine, ' Renoir was to say when talking about himself to his son Jean, the film director; ' the bourgeoisie adores martyrs ... especially after a good lunch with plenty to drink. ' But hand-made porcelain was soon to yield to the competition from mass production, and Renoir moved on to painting fabrics and fans in another workshop, where he was involved in work for foreign missions.

In 1862, having attended evening classes in drawing, Renoir enrolled for the regular course in painting at the École des Beaux-Arts. With his savings he paid for lessons at the studio of Charles Gleyre, one of the best known and least expensive academic teachers. There he attended between 1862 and 1864. His treatment of the nude and classical subjects lacked discipline, according to the scholastic rules. Renoir painted with dedication. In Gleyre's studio he met Frédéric Bazille, Alfred Sisley and also Claude Monet, an impatient student who already had decided ideas about painting landscape, and who shared with Eugène Boudin,

3

a painter of delightful seascapes, the conviction that land-scape, far from being the 'art of decadence', as Gleyre said, was the most vital form of painting; and Monet talked of the new masters, of Jongkind, Delacroix, Courbet. But Renoir, like Sisley, took a number of examinations at the École des Beaux-Arts – in anatomy, drawing, likeness, per-spective – and at the same time used to go, with his friend Fantin-Latour, to the Louvre. It was with regret, according to Bazille, that he saw the closing of Gleyre's studio in 1864; but that summer he was with friends at Chailly-en-Bière, near the Forest of Fontainebleau, attract-ed by what Monet and Bazille had said about it. In the places where the 'Barbizon masters' lived, Renoir painted *sur nature*, and got to know one of these masters, Díaz de la Peña, who advised him and helped him buy canvases and paints when he found out how short he was of money. Renoir was soon to destroy his *La Esmeralda*, an academic painting accepted by the Salon of 1864, because now he admired Corot and Courbet, whom he met in the summer of 1865 at Marlotte, one of the country villages near the Forest.

In that same year, 1865, the Salon accepted his *Portrait of William Sisley* (the father of his painter friend), and also *Summer evening*. Renoir lived cheaply in Mallet's inn or in the one owned by Mère Anthony, where Sisley used to go with his brother Edmond, and also the architect turned painter, Jules Le Coeur. Renoir met Lise Tréhot, a fascinat-ing eighteen-year-old who was to be his mistress and model until 1872. Le Coeur and his friends; Lise's sister, Clémence Tréhot; Lise herself and Sisley – these were the subjects of numerous paintings done in this first period. In 1864 Jule's brother, Charles Le Coeur, who was an architect, founded the Musée de Pau – according to recent research by Cooper – and it was here in the home of the society of Friends of Art that in 1866 Renoir exhibited a number of paintings.

Commissioned by Charles, Renoir also decorated two ceil-ings in a house of Prince Bibesco, going back to the style of the eighteenth century, as is evident from some drawings kept by members of the Le Coeur family. Jean Renoir

has said that his father must have decorated a score of Paris cafés, but not a single example remains to us.

Certainly Renoir's way of going about things was rather odd. As he was to say of himself, ' I've never sought to direct my life, I have always let myself be carried along by events. ' And indeed it was in his nature to love life and painting with carefree enthusiasm, although the story of his life and the values expressed in his painting show that, even if he did not parade his convictions as did other leading personalities of the time, Renoir still stuck to what he believed. Thus he was reluctant to argue; he left the talking to the less easy-going Monet, or to the profound and tough-minded Cézanne, to whom Bazille introduced him one day with Pissarro, and who was to be a lifelong friend. Of a warm and cheerful disposition, content with little, Renoir took life, he said, for what it could offer him. But in his painting the casualness was only on the surface, although it was perhaps the chief element in his marvellous facility.

The story of his days is a simple one, spent at home or at the Louvre, in the Chailly woods and the Paris streets, in country inns and city salons; for he did not shun smart society, even if he preferred the simple life. He was grateful to Prince Bibesco who had introduced him to the world of the aristocratic boudoirs, and who had given him work and brought him clients. Renoir wanted above all to exhibit at the official Salon; quoting Delacroix, he was ready to be realistic and argue that it was essential for a painter to be known by the public and thought well of by collectors. But he had little luck with the Salons of 1866 to 1879. In 1866 a *Landscape* was refused, in spite of the intervention of Corot and Daubigny; *Diana* was refused in 1867. On the other hand, he had a certain success in 1868 with *Lise with a parasol*, and Manet praised the *Portrait of Frédéric Bazille*. With Bazille, who gave him help, he shared a studio in the Rue Visconti and, from January 1868, one in the Rue de la Paix, which Monet also frequently visited.

Bazille did a portrait of the twenty-six-year-old Renoir (the painting is now in Algiers), in a casual pose but with an

earnest, thoughtful expression. In 1868 and 1869 Renoir frequented the Café Guerbois, where he, like the others in the group, ' stocked up with enthusiasm ', as Monet was to put it, listening to Manet and the elder Pissarro arguing with Degas. In the summer of 1869 he painted with Monet some landscapes at Bougival. Their study of the effect of light on the waters of the Seine at La Grenouillère produced some revolutionary ideas about colour and the first ' impressionist ' paintings.

The group associated with the Batignolles district of Paris where ' Manet's gang ' used to meet, and which had been brought together by the Fantin-Latour painting exhibited at the 1870 Salon, was dispersed by the Franco-Prussian War. Renoir was called up into the Cuirassiers and went to Bordeaux, then to the Pyrenees. He endured military life from July 1870 until March 1871. During the upheaval of the Commune, Renoir, ' neither a hero nor a defaulter ', hardly left Paris except to go to the nearby Louveciennes, where his parents lived, and to paint at Marly with Sisley. In 1872 he had another disappointment when the Salon rejected *Parisiennes in Algerian costume*, but he was nevertheless fired by fresh enthusiasm; he painted views of Paris, among which (in 1872) was *Pont-Neuf*. Between 1872 and 1873 he painted *Ride in the Bois de Boulogne*, evoking loud protests from one Captain Darras: ' Blue horses – who ever heard of such a thing? ' This eight-foot painting, for which Mme Darras posed, was rejected by the Salon of 1873. The academicians were not, however, so rigid as ten years earlier, and on 15 May they opened at the Palais de l'Industrie an overflow from the Salon which was called the Exposition des Refusés. The critic Castagnary admired *Ride in the Bois de Boulogne*. Another critic, Théodore Duret, helped Renoir in various ways; having met him at Degas's studio and listened to the praise lavished on him, he bought *La Bohémienne* and not long after *Lise*. Another lucky meeting was that with Durand-Ruel, the perceptive dealer who was the first to back the impressionists, and who as early as 1871 exhibited a painting by Renoir, among others, in London. Renoir was able to rent the studio in the Rue Saint-Georges. He was

thirty-two, thin, and he painted in nervous spasms and twitches, singing all the time; he had bright piercing eyes, one of which blinked continually, and thin restless fingers that 'hustled the brush along', as Thadée Natanson was to write. He divided his time between Argenteuil and Paris. He painted his friend Monet at work, and also did various paintings of Monet's wife Camille.

In 1874 the two friends, returning to an idea of Bazille (who had perished in the battle of Baune-la-Roland in 1870), put on the first exhibition of the 'group', in collaboration with Pissarro and Degas. It was held on the premises of the photographer Nadar, in the Boulevard des Capucines. Renoir was opposed to hard and fast ideas and provocative labels: he saw no need to talk of a 'new school'. His common sense was impatient both with artistic codes and with scandals. Renoir, who had been given the job of preparing the exhibition, while his brother Edmond drew up the catalogue, was represented by seven paintings, among them *Dancer* and *The box*. The critics were scathing and the public stayed away. Only at the auction sale held, on Renoir's advice, at the Hôtel Drouot in March 1875, did Monet, Sisley, Berthe Morisot and Renoir manage to sell a number of paintings, although at derisory prices and to the accompaniment of mocking remarks from onlookers. Two Renoir paintings sold were a replica of *The box* and *Pont-Neuf*, the latter for 300 francs. But one happy development was the meeting with a new collector, Victor Chocquet. Renoir immediately took him to meet his friends, and a little later he introduced him to Cézanne. When Renoir rented, for a hundred francs a month, the house in the Rue Cortot, he found his models in Montmartre among the *midinettes* that he met in the streets or among the merrymakers at that popular haunt, the Moulin de la Galette. Friends who went there included George Rivière, and also Franc-Lamy and Cordey, two ex-students of the École des Beaux-Arts, pupils of Lehman. Lestringuez and Lhote, and his brother Edmond, went there too.

At the impressionists' third exhibition, put on by Caillebotte in 1877, Renoir showed *The swing* and *Moulin de la*

Galette, portraits of Mme Chocquet and her daughter, of Jeanne Samary, the fascinating actress he had met at the house of the publisher Charpentier, the portrait of Mme Daudet, landscapes and flowers. But not even the attempt by Georges Rivière to explain his friends' style of painting, which he did in collaboration with Renoir in a series of articles from 6 to 28 April, could capture the public's interest, and the articles were brushed aside as mere puffs for the exhibition. The buying had to be done by the same old crowd – Chocquet, Caillebotte, Duret, sometimes Père Martin who had recently bought *The box*, and a few others. Often Renoir was forced to pay bills with pictures in order to live. However, around 1876 he got to know Charpentier and began going to his house where he used to meet Daudet and Zola, Flaubert and Goncourt, Maupassant and Gambetta, Chabrier and Turgenev; and having become a regular client of the Café de la Nouvelle-Athènes, he certainly met Degas there.

In 1878 Renoir withdrew from the group exhibition. ' I don't want to fall into the folly of believing that a thing is bad because of where it happens to be. In a word, I don't want to waste my time hating the Salon. One must simply paint as well as one possibly can – and that's all. ' He believed too that the group put on their exhibitions too frequently; and, as Cézanne said, these exhibitions, instead of presenting the impressionists, were a vehicle for ' *coopératifs* '; this was because outsiders were included, painters invited by Pissarro or Degas. In 1878 Renoir sent to the Salon *The cup of chocolate*, now in a private collection in Detroit, and once again he appeared in the catalogue as a pupil of Gleyre. He met up with Guillaumin, Sisley, Guérard, Cabaner, Père Tanguy and others at the restaurant owned by Eugène Murer, which Renoir and Pissarro had decorated with portraits of the owner and his sister – pictures for which they were miserably paid. Renoir did not take part in the group's fourth exhibition in 1879, but instead he scored a success at the Salon with *The Charpentier family*. This pleased Pissarro: ' I think he's launched. All to the good! It's so hard being poor '. And Monet, perhaps musing in his terrible poverty on his

friend's success, decided the following year that he too would exhibit at the official Salon. Degas might grow angry at his friends' betrayal, but he had to put on the fifth exhibition, in 1880, without them. Renoir, full of driving energy, was looking for new subjects to paint – in Berneval, in Normandy, at Chatou. But new disappointments were in store for him: his and Monet's pictures made a poor showing at the 1880 Salon; when Zola was asked by Monet, Renoir and Cézanne to write in their defence, he in fact published some articles which expressed rather serious reservations about their painting: '. . . their powers are not equal to what they are attempting to do.' The friends themselves began to adopt different approaches. In 1881 Caillebotte tried to mould the group together again and accused Degas of having caused a split by bringing in outsiders like Raffaelli and Forain, Lepic and Legros, Moreau, Bracquemond and Zandomeneghi.

Not until 1881 did things improve for Renoir. Durand-Ruel began buying again, in monthly instalments, and in the spring of 1881 Renoir was able to go on a trip to Algeria. That summer, back again in France, he was the guest of the diplomat Paul Bérard at Wargemont. He met Aline Charigat, who was to become his wife, and painted her in the *Luncheon of the boating party* which he did at the Fournaise restaurant on the Seine. From the latter part of 1881 until early in the new year he was in Italy, seized with a feverish desire to see the work of Raphael, perhaps inspired by Eugène Müntz's book, published in 1881. Renoir stayed in Venice where he was enchanted by the Doge's Palace, and by St Mark's; he looked afresh at Veronese, discovered Tiepolo (as he wrote to Mme Charpentier), and admired Carpaccio. In Florence he was staggered by Raphael's *Madonna of the chair*, and in Rome he was equally full of admiration for the frescoes in the Vatican and the Farnesina. In Naples he was impressed by the paintings at Pompeii, and in Palermo he painted a portrait of Wagner, who posed for him for a mere half hour.

When he landed back in Marseilles in January 1882, he stayed with Cézanne at l'Estaque; again he began painting in the open air, but he soon fell ill with pneumonia.

After a brief trip to Algiers, he returned to Paris where he showed twenty-five paintings at the seventh exhibition put on, in 1882, by Durand-Ruel in the Rue Saint-Honoré. Then he began travelling again: in 1883, while Durand-Ruel was preparing for him a one-man show in the Boulevard de la Madeleine, Renoir was in Guernsey; in December he was on the Côte d'Azur with Monet, then at l'Estaque with Cézanne. He was constantly making drawings; reading Cennino Cennini's *Libro dell'Arte* had further convinced him of the need to acquire a deeper knowledge of drawing. He was also preparing the big painting *Bathers*, which he began in 1884.

Perhaps because of the dismay caused by his new paintings (in the Ingres style, as people said), Renoir exhibited with Monet from 1885 onwards at the international exhibition put on by Petit, a rival of Durand-Ruel, and also at the Societé des Vingt in Brussels. In spite of the fact that his work was criticized even by his friends, Renoir felt that his anti-impressionist phase was beneficial. In the summers of 1888 and 1889, at Jas de Bouffan and Essoyes, his wife's native village, where he went often, he again began painting in the open air. In 1890 he went back for good to what he called his gentle and light *(douce et légère)* style of painting. He had a studio in the Boulevard Clichy, and once again he began dining with his friends Bérard, Geoffroy and Clemenceau, and listening to their political discussions – though politics interested him little. His good sense and human understanding was poured straight into his painting, into a ceaseless spate of work. In 1892 he enjoyed a triumph at the show put on by Durand-Ruel. There was a growing number of buyers and commissions.

His family was also growing: Pierre was born in 1885, and Jean, the future film director, in 1894. In 1894 Renoir, executor to his friend Caillebotte, had to battle with the ministries and the Louvre in order to carry out the legacy of Caillebotte whereby his collection of impressionists was left to the Louvre. In 1898 Renoir had his first serious attack of arthritis, from which he had suffered ten years earlier. From Essoyes he moved south, to Cagnes-sur-Mer.

And he also travelled: in 1892 he went to Spain with Gallimard, and in 1895 to London and Holland, where he visited museums. In 1900 he showed pictures at the Exposition Centennielle and was awarded the Légion d'Honneur. In Cagnes, where he lived from 1903, he bought a property, Les Collettes; between 1905 and 1909 he built a new house there in which he was to live during the last ten years of his life. Although his rheumatic condition grew progressively worse, he still painted with gusto. At the Salon d'Automne of 1904 his retrospective exhibition was a triumph. Between frequent cures and periods of convalescence at Aix-les-Bains, there were bouts of hectic work. Those who visited him after 1908, such as Albert André and the American painter Walter Pach, were astonished by his optimism and the speed with which he worked.

In 1907 he began sculpting, and he did at least two sculptures with his own hands; in the following years, when paralysis hampered him, he directed young assistants, students of Maillol. In 1910 he went on a trip to Monaco. A fresh attack of paralysis in 1912 condemned him to a wheelchair, but, in spite of crippled fingers, he went on drawing and painting. Treatment from a Viennese doctor enabled him to take a few steps round his easel, but it was a great strain. 'I give up,' he said. 'If I have to choose between walking and painting, I'd rather paint'. In those last years his palette was made up of about ten colours, among them yellows, crimsons, Venetian red, French vermilion, emerald green, cobalt blue, ivory black. He spread the colour in thick, broad strokes, full of pulsing opulence.

In 1915 his wife Aline died after the great strain of nursing back to health her sons Pierre and Jean, wounded in the war. Renoir's sole consolation was the presence of his son Claude, born in 1901. But he survived all difficulties to go on living for painting. A few months before he died he had the joy of knowing that his *Portrait of Mme Charpentier* had been accepted by the Louvre. On 3 December 1919, while he was dying at Les Collettes, he was thinking about the last bouquet of anemones that Nénette, the maid, had picked for him on the ' intoxicating ' hillside of Cagnes.

Works

The *Portrait of Romaine Lancaux* in Cleveland is one of the few early Renoirs to have come down to us, because the painter destroyed with his own hands most of what he painted before 1866. In 1864 Renoir was attempting, by emphasizing the effect of light and by a certain luxuriance of form and colour, to effect a marriage of Ingres and Corot. But it was his first contact with nature in the Forest of Fontainebleau, in that and the following years, which helped Renoir, not only to take an open-minded approach to the treatment of landscape and figure painting, but to seek a new conception of painting. Another factor was the stimulating personality of Monet. It was in the series of landscapes painted between 1865 and 1866 that the artist's highly individual use of tone values began to mark him out from the pictures then being painted by Monet, Sisley, Pissarro and Cézanne. He conjured up the sunlight, playing on forest glades and streams, of the Barbizon masters; if his painting did sometimes include the 'mushrooms, dead leaves and moss' he admired in Díaz, Renoir was soon to switch to gentle leafy trees, enlivened with subtle reflections and the fine steady quality of light associated with Corot, and endowed at the same time with the rugged strength of Courbet. These were the unconscious or acknowledged influences that ran through his work in those years when there were already signs of his remarkably happy relationship with nature.

His successive enthusiasms, first for one master, then for another, gave an impression of slow progress during those formative stages, but a constant new factor was a subtle and vibrant use of colour that bespoke a sure hand and eye. Already there is that unmistakable tangible quality in the brushwork that gives strength to the big *Vase of flowers* with its white irises, peonies and daisies, which he painted in early 1866.

When he went back into the forest in the summer of 1866, he was able to think of Courbet without his entrenched

theories, and of Manet without that painter's desire to shock, for in the gathering of friends he painted in *The inn of Mère Anthony* he achieved a relaxed familiar atmosphere. Is there a hint of Courbet's *Dinner at Ornans*, or of some older style of naturalism, in the little group of figures, or of some meal painted in a spot somewhere in Flanders, Lombardy or the Veneto, centuries earlier? This was the time when Renoir, after doing a number of forest scenes, was pouring out his ' astounding facility ', as John Rewald called it, in the magic naturalism of some still-lifes of flowers (Fogg Art Museum, Cambridge; Paul Mellon collection, New York). These paintings have smooth brushwork with a pearly finish like fine porcelain overlying the colour. Also painted in 1866 was *Lise sewing* (Reves collection, London); this picture, like a less restrained Corot, is bathed in a bare pinkish-grey and brown light.

Diana (*pls 2-4*), which Renoir painted between 1866 and 1867, was not treated as a subject from mythology but was his first attempt at a nude. He uses thick smooth pigment spread with a palette knife, and there are echoes of Courbet and Ingres. It is hardly surprising that the picture was rejected by the Salon of 1867, when we note the crude colouring that surrounds the pale gold of this dewy, uncertainly executed nude. In these early works there is evidence of a constant tug-of-war between various influences, between his studious workmanlike approach and his intoxication with nature, so that it is difficult to pinpoint precise influences or to say where the two parts of him come together. Renoir, cheerful and easy-going as he was, never made a secret of his conflicting loyalties: Corot, Courbet, Ingres and Delacroix; Boucher, Fragonard and Watteau; and also Lancret and Goujon and the great Louvre school; and along with Fantin-Latour, who copied everything. he admired Titian and Veronese, Velázquez and Rubens. But they were influences that Renoir was to absorb with experience. At the beginning he was searching for himself, fired with a love for truth, and with a sharp eye for simple things, stripped of myth or historical association. So much so that he painted people and things almost as an exercise in colour harmony. And Renoir, who seems the most down-to-

earth of all the impressionists – and perhaps he never threw off a hearty bourgeois mentality – had no more luck than his companion painters in the years when painting was acquiring a new way of looking at the everyday world. To Renoir, as to his friends, the critics were usually hostile. An exception was William Bürger who had already seized on the new treatment of light in Monet's *Camille* and who in 1868 was to give the first sympathetic reception – and for the next decade the only one – to Renoir's *Lise with a parasol* which was shown at the Salon of that year. In this painting, begun in the summer of 1867 and preceded by several figure studies in the open air (*Girl with a bird* in the Barnes Foundation, Merion, Pa., and *Lise holding a bunch of wild flowers* in a private collection in Paris), the girl appears in a long white dress round which is a black sash in delicate and yet striking contrast; she stands bathed in sunlight, and Renoir has put in greenish reflections and grey and pink shadows cast by the foliage and the parasol. It has the effect of another immediate ' slice of life ', like Whistler's *Girl in white* which was shown at the Salon des Refusés in 1863, like Manet's *Olympia* which caused such uproar in 1865, and like Monet's *Camille*.

Lise was the prelude to that other deeply felt and more polished work, finished in 1868, *The Sisleys*. This painting clearly showed the connection between the effect of light on colour and that ' intimate feeling for a subject ' (as Baudelaire would have called it), something which relates a painting to the essential harmony of nature. That fortunate group of painters – Manet, Degas, Monet, Sisley, Pissarro, Cézanne – would have been overwhelmed by the profound experience of a new trust in nature and life, without the happy example of Renoir's painting. The ' beauty at ground level, palpable and exploitable ', of which the Goncourts wrote in their new novel, *Manette Salomon*, published in 1866, seems to flow in a joyful stream from Renoir's deep and simple curiosity. What was later to be called the diversity of art, the irregular as an indispensable component of beauty, showed itself even in Renoir's earliest paintings. At this period in his life Renoir was more closely influenced by Manet's work. The *Portrait of Frédéric Bazille* (*pl. 5*)

won the approval of the *maître*. This was the only time, perhaps, that Manet fully appreciated the work of his 'apprentice', Renoir, and he was always saying later, of other pictures, 'Ah, that's not as good as the *Portrait of Frédéric Bazille*.' Renoir wrote to his friend Le Coeur that he was discovering 'real painting' and was giving up using a spatula because it made it impossible to go back on a painting or to change a figure, after the first sitting, without scratching the canvas. Courbet's 'heavy-handed' painting was not for him; he preferred to paint in ' little strokes which help me to merge one colour into another . . . I have my funny little ways, I like to fondle a painting, to stroke it.' Renoir felt that Cézanne was right about Manet when he said that he had opened 'a new era in painting' while Courbet was 'still a traditionalist'.

But Renoir always got on with the actual business of painting and did not commit himself to one particular path. He liked working in the open air, but he also went to the Louvre. He took little part in the discussions at the Café Guerbois, but his ideas, expressed in letters and later to biographer friends and critics, differed from those of Monet and Pissarro. He could not see why they should criticize Corot for 'touching up his landscapes in the studio' or why they should 'abhor Ingres'. He said that he thought Corot was right and that he 'secretly delighted in the pretty stomach in *The spring*' and in the neck and arms of *Mme Rivière*, both of which were the work of Ingres, whom Monet disliked, but who deeply impressed Degas. Only Baudelaire, great poet and critic that he was, appreciated the 'marvellous tact' that Ingres had shown in his choice of models; and 'the beautiful shapes, rich natural scenery, and serene flowering life' that are there under the ivory surface of that great and strange 'academic' painter. Perhaps it was when his experience was maturing, towards 1870, that Renoir, who was an avid reader, meditated on the writings of the poet who, more than any other, understood the proud and troubled vision of Delacroix.

Renoir was to grow above all as a master of colour. His friendship with Monet, with whom he was painting on the banks of the Seine around 1869, stimulated him to develop

ever-greater skill in colour harmony; *Skating in the Bois de Boulogne*, painted in the winter of 1868, was early evidence of this. However Renoir was hostile to the cold; ice and snow, ' that leprosy of nature ', held no attraction for him. Summer was his season.

At La Grenouillère on the Seine, with Monet, Renoir opened his eyes to the full quivering excitement of colour; nature is now caught in full flight and the eye receives sunlight on branches, water and grass, and on the motley clothes worn by the passing crowd. The only difference between nature and the canvas is one of proportions, and flowing between the two are touches of colour with no sentimental frills; now we no longer have an *Embarkation for Cythera* (as painted in a delicate dreamy style by Watteau, whom he admired), but simply a straight re-creation of light and colour by the Seine, as it was seen by Frédéric Moreau, the character in Flaubert's latest novel, as he came up by steamer from Le Havre to Nogent-sur-Seine. The period when he was working with Monet, and, soon after the interruption caused by the war, with Sisley at Marly, showed early signs of a more conscious search for the play of light on colour, and those signs are unmistakably there in his work. Compared with the rougher and more rapid brushstrokes of Monet, with the withdrawn and intimate world of Sisley, and with the painstaking work of Pissarro, Renoir's landscapes are full of grace and life; they stand apart also for their variety of brushwork.

It was during this period, when Monet and Renoir were blazing a fresh trail, that a new way was opened for impressionism; if Renoir gradually moved towards a freer and more flowing style of painting, it was because he felt that the world as he saw it demanded a continual reinterpretation of the masters. In 1870 there were still echoes, at once more restrained and more human, of Courbet in *Woman bathing, with a dog* and of Delacroix in *Woman of Algiers*. Renoir ' is making a great mark with a picture of an Algerian woman that Delacroix would have signed, ' wrote Arsène Houssaye. But the range of colours and above all the woman who posed for it (again Lise), make this picture and the one that followed it (*Parisiennes in Algerian costume*,

rejected by the Salon of 1872) two highly personal versions of Renoir's exotic view of workaday things. It must not be forgotten that it was in Delacroix's *Women of Algiers* that Baudelaire had noted 'his prettiest and most flowery painting'. But Renoir lays bare 'the stench of a place of ill repute which leads us quite soon to the bottomless limbo of sadness' and which lies at the core of the high romanticism of Delacroix. On the other hand he brings out the feminine presence, with its 'adorable imbecility', as he put it, in an almost blatant feast of the senses. His exotic *Studio at Les Batignolles* is a different 'little inward poem', full of serenity and silence, but also of high spirits and what Baudelaire had called 'the scent of the seraglio'.

At intervals between 1871 and 1874 Renoir went back with Monet to Argenteuil where he painted numerous landscapes. These were paintings in which he used intensely vibrant colour, aided by his remarkable feeling for atmosphere and his response to nature in the open air. A comparison with Monet's work, which is very similar but surer and more tense, reveals that Renoir relied on his easy-going response to what he saw, and colour in his hands wrought its own magic fusion of nature and art. It represents a total immersion in the subject, achieved by a great range of brush-strokes – tiny and close, or broad and spaced, or long and sinuous – which are nevertheless supremely controlled, and which therefore come miraculously together, full of throbbing life. That inner life is what expresses the season of the year, or just a moment in time, caught like a vague memory in the hot liquid colour. In 1872 he painted the beautiful *Pont-Neuf* to which there had been a prelude in 1868 in the colder and cruder *Pont des Arts* (private collection, New York). Later, with denser dabs of colour, came *Pond with ducks* (in the Louvre), *Seine at Argenteuil* (in Portland, Oregon) and *Monet working in his garden at Argenteuil*. Also, and astonishingly different, there was *Path climbing through long grass* which shows a grassy bank full of flowers in summer, with patches of colour and figures (*pl. 15*).

Working at this time with Monet, Renoir showed (as did Pissarro and Cézanne at Pontoise) that he and Monet were aiming at the same things; this is obvious from his increas-

ing skill with the technique of pure colour, by which he could capture a slice of nature, and even more the feeling of a particular season of the year, almost 'the essential character of a day if not of an hour in that day,' as Rewald writes. It was no longer a case of interpreting nature, but of faithfully observing it. Nature became the very source of pure sensation and opened the way to a new participation in being and in the universe.

In 1873 Renoir was able to rent a studio in the Rue Saint-Georges, in an unfashionable area far from the left bank; the studio was very light in the summer and, testifies Rivière, was furnished almost exclusively with easels, a few cane chairs, and pots of colour. His best friends came to see him there; but the surroundings were still squalid and he lived in poverty. Renoir plunged into a frenzied spate of work, and painted many of his friends; his female models were *demi-mondaines* picked up around Montmartre. Now that Lise was married, he used the quiet blonde Nini, or Margot, the carefree chatterbox. To Renoir nearly every setting was congenial – the studio or the boulevard, a garden or a theatre.

It was in the year 1874 that he painted the splendid pictures shown at the first exhibition, put on at Nadar's studio, of the Société Anonyme; among these were *Dancer* and *The box* (*pls 10-11*), a marvellous picture, full of a precision and subtlety that defy description; indeed it is, as Longhi wrote, 'perhaps the most felicitous painting of modern times'. The colour flows limpidly over the picture and achieves a balance, rare in daylight (the light of Renoir's studio), from the lively colours in the woman's stupendous dress – white, blue and black – and the same colours in the man's clothes. That balance is achieved with even greater subtlety in the portraits of the sixty-year-old Victor Chocquet; in these Renoir suggests more than he states: he penetrates the character of this 'apostle' of impressionism, as Duret described him. It is the same in *Woman reading* (*pl. 19*) where the face and hair are a fiery whirl of orange and pink ochre against mauve. But in the first studies for *Nude in the sunlight* (*pl. 20*), the light streaming through the foliage plays on the body exposed to the clear air.

In 1876, the year in which Degas first became a devotee of the music halls and *café-concerts*, Renoir began in Montmartre a series of paintings in which there was a rebirth of his warm human interest; he no longer concentrates solely on portraits or single figures, but paints groups of friends and the crowds at the Moulin de la Galette (*pls 22-5*). ' I've always liked ', he was to say, ' to feel people swarming around me. ' At the same time the quiet gardens provide the setting for *The swing* (*pl. 21*). In this great painting Renoir captures all the play of light and shade produced by sunlight on clothes and faces, and the result is a chiaroscuro of dancing colour, a shifting kaleidoscope; it is bound together in a serene harmony of dominant tones, and yet it all seems spontaneous and uncalculated.

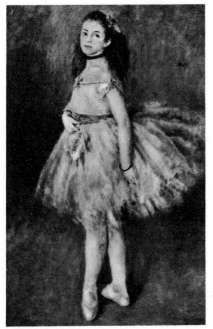

Dancer (see p. 33)

For Renoir the years 1875 and 1876 were very productive but were not attended with critical acclaim; he made the acquaintance of Chocquet, a customs officer who wanted Renoir's paintings to place alongside those in his collection by Delacroix, but otherwise few new admirers or collectors came along. Indeed, on the occasion of the 1876 exhibition put on by Durand-Ruel, the powerful critic of *Le Figaro* wrote: 'Try to explain to M. Renoir that a woman's body is not a heap of decomposing flesh with green and mauve patches denoting a state of complete putrefaction!' Such words, while they unwittingly say something about Renoir's fresh approach, are nevertheless a distortion of the truth. Not even in the most extreme lacerations of Renoir's last works, where the colour flows in such a way as to suggest an overhelming private vision of nature, is there any lack of his deep fidelity to colour in its most specific demands. And yet there are often signs, in the work of both Renoir and Monet, of the break-up of form that was to come in the painting of a later age, for they were well in advance of their time. Renoir, nearer to nature in its human manifestations, anticipates the 'luxury, calm and delight' of Matisse.

There was to be no better reception, either, for the third exhibition put on by the impressionists, as they called themselves now after the uproar caused by Monet's picture *Impression: rising sun* which was shown at the 1874 exhibition. With the difficulties in which he found himself – and they were no less acute than those of Monet or Pissarro – Renoir felt it was advisable to exhibit at the Salon of 1878 where he was represented by *The cup of chocolate* (private collection, Detroit); but at the following Salon he had his first success with a portrait, *The Charpentier family* (*pls 28-9*).

This is a vast and perhaps rather showy picture, but one that is invigorated with an 'imposing magnificence' (Rewald) and is built – there can be no other word – on dazzling, sumptuous colour; it also shows Renoir's delight in the richly varied setting of Mme Charpentier's Japanese drawing room, the fine clothes by the fashionable *couturier* Worth, and the exquisite furniture and the decorations with

their subtle colours. The painter's sharp eye sweeps over this rarefied setting where Madame held her intellectual gatherings of famous writers and academic painters. George Besson relates how Renoir observed all with his eagle eye including the attractive young Jeanne Samary and her radiant expression. Renoir himself recalled meeting Flaubert at these gatherings, firing off bitter jests in a loud voice, and the ambitious Zola who always seemed to be arguing rather than talking, as Rivière noted. Others who came to the house were Edmond Goncourt, the painter Carolus-Duran whose bizarre behaviour had earned him the nickname of 'Caracolus-Caracolant', the raw-boned writer J.-K. Huysmans who was then a new convert to naturalism, and also Henner and De Nittis; besides which there were Manet and Degas, Ernest d'Hervilly and Alphonse Daudet.

Also relevant, perhaps, was the series of 'society portraits' he had agreed to do for Charpentier and his colleagues. And in the paintings he did in 1879, and more so those in 1880, there is a more severe figure composition, though always lightened by wonderful transparent colour effects. Examples are *End of the lunch* (Frankfurt), *At La Grenouillère* (*pl. 32*) and *On the terrace* (*pl. 31*), all dating from 1879; another example is the *Portrait of Irène Cahen d'Anvers* of 1880, now in the Bührle collection, Zurich. 'Renoir', wrote Cézanne to Zola on 4 July 1880, 'has some good commissions to do portraits.' These came from Grimprel, Bérard, Cahen d'Anvers and a few other exceptional buyers that Renoir met through the Charpentiers or through the collector Ephrussi. Meanwhile Renoir was gaining a deeper knowledge of Titian, Rubens and Van Dyck, and also of his beloved Watteau and Fragonard.

In that same year, 1880, he protested against the Salon jury who, in the arrangements they made for hanging, favoured 'a little privileged group'. First he published an article, which went unnoticed, in the *Chronique des Tribunaux* of 23 May; then, together with Monet, he composed a letter to the Under Secretary of State for Fine Arts and, through Cézanne, sent it to Zola, famous now for several of his novels, so that he would publish it in *Le Voltaire* and thus demonstrate 'the importance of the impressionists'. But

from the four articles that Zola wrote (beginning on 18 June) it was clear that he did not understand the impressionists. They have not won their fight, he wrote, because they show themselves to be 'incomplete, illogical, intemperate, impotent'. Monet too, during his exhibition on the premises of the paper *La Vie moderne*, made some bitter comments to a writer on that same paper. He said that the 'little church', which had once been united, was now a 'banal school that opens its doors to the first dauber who comes along'. There was plenty of angry protest – Degas, resentful at being let down by Monet and Renoir, went round saying that Renoir 'lacked character', and showed his defiance by going on with the group show and inviting other painters to take part. Renoir, on the other hand, had the good fortune to get new commissions and was working intensively. In one day, as he wrote to Mme Charpentier, he started on three portrait

Feeling strangely unsettled, Renoir promised Duret he would go to England, but at the end of February 1881 he suddenly went off to Algiers, a favourite city of Delacroix and also of Monet (who had been there in 1861 on military service), and one that had the atmosphere of a sunlit village: besides, some of his friends were there – Lhote, Cordey and Lestringuez. It was his first trip abroad, and coming at that time it did him a great deal of good. He painted very little but looked round about him with fascination; now he was convinced again about impressionism, and the 'extraordinary richness of nature'. He mentioned the aim of this trip in a letter to Durand-Ruel: 'I have kept away from all painters here in the sun, so that I can really think and calm down a little. I think I've sorted things out. I may be wrong, but I would be very surprised if I were'. On this and the second trip to Algiers, exactly a year later, he painted a number of landscapes – *Banana plantation* and *Moslem festival at Algiers* (both in the Louvre) – and some fantasies which capture the magic of the sun and in which terraces and streets are transformed in the brilliant light into gold and purple. In the dazzling Algerian sunlight, a beggar appeared like 'a magnificent prince out of the *Thousand and One Nights*', he wrote to Rivière.

He returned from Algiers in the spring, and with fresh enthusiasm began painting again at Chatou and at Bougival. ' I'm struggling with blossoming trees, and with women and children, and I don't want to see anything else,' he wrote on 18 April to Duret from Chatou – where he met up with Whistler. He was evasive about the proposed trip to England. He asked to be excused for being ' capricious like a beautiful woman', but he had all the models he wanted in front of his eyes. Indeed, some years later he could only dismiss as absurd Gauguin's mania for seeking subjects in exotic islands. ' One can paint so well at Les Batignolles,' he said. He started going again on trips along the Seine where there were always opportunities for painting. The warm, relaxed atmosphere of one of those outings is marvellously suggested by *Luncheon of the boating party,* done in the summer of 1881 during some happy sessions with friends at a restaurant at La Grenouillère. Marcel Proust in a novel was to attribute this painting to an imaginary artist, Elstir, in a penetrating characterization of an impressionist.

Before the end of the year Renoir was in Italy, seized with ' a fever to see the work of Raphael'. There is no doubt that the new currents flowing through French art around 1880 brought a particular spate of interest in Italy, and that this affected Renoir. Even more than the conversation of Jacques-Émile Blanche, a student of painting at the academy with whom Renoir stayed again in the summer of 1881, he must have found particularly useful a certain book mentioned by Vollard. It was in 1881 that Eugène Müntz, a great expert on Italian art then working in the library of the École des Beaux-Arts (where he acted as a guide at that time to Georges Seurat), published the excellent *Raphaël, sa vie, son oeuvre, son époque.* Renoir's letters from Italy, though embellished here and there with rough-and-ready expressions, speak of his genuine astonishment at personally rediscovering the work of a painter whom he would never have believed so full of ' knowledge and wisdom'. And it was the same thing in Venice, where he painted *The Lagoon in the sun* (Kramarski Collection, New York), and *St Mark's* (Staatsgalerie, Munich); he was excited

23

by the paintings in the Carpaccio galleries and, above all, by Raphael's *Madonna of the chair* in Florence.

In Naples there was another surprise in store for him; the Pompeian paintings, in which he discovered, as he was to say, a 'sense of volume, and yet there is no volume.' He thrilled to find in them a link with Corot. These artists of the distant past, he said, had in their painting created so much with so little. He also admired Titian. The *Blonde bather* (Kenneth Clark collection, London) which he painted, according to Blanche, on a boat in the Bay of Naples, already has, with her softly golden figure, something of a friendly, sunny *Violante*, because she is idealized and yet earthly. He wrote to Durand-Ruel on 21 November that he kept painting and then starting again because of a new mania for experiment. 'I'm not happy, and I keep scrubbing out again and again . . . I'm like the children at school; the clean page is going to be filled with good writing and then suddenly – it's all a mess. I'm still making messes – and I'm forty years old.'

When he joined Cézanne at l'Estaque he plunged with renewed strength into open-air painting. And yet *Olive Trees at l'Estaque*, painted in 1882 (Hirsch & Adler Galleries, New York) or *Rocks at l'Estaque* (Museum of Fine Arts, Boston) are ablaze with colour and light. Hidden somewhere below is a structure that binds together the even denser blue, orange and mauve blobs that represent trees and bushes in another painting of l'Estaque in the same Boston Museum. Perhaps in Cézanne's 'patrie des oursins' Renoir was looking for his own 'Poussin in nature', so that, if he looked hard enough, he would find the breadth and simplicity of the classical painters. He followed Cézanne, that tireless searcher for subjects, out into the winter sun. But he caught a chill which turned to pneumonia. Edmond came, and he and Cézanne nursed Renoir with every care. In the meantime Durand-Ruel was making preparations for the seventh impressionist exhibition, in which he intended to show the best in the group, but also some of the newcomers. Renoir wrote and authorized him to include his paintings, although he would rather not be shown alongside Guillaumin or the new pair, Pissarro and Gauguin. But he

stipulated that this should not prevent him exhibiting at the Salon. 'That lets me out of the revolutionary side of the business, which worries me,' he wrote. And now, more than ever, he was working to develop a sharper line and more emphasis on form.

After a short stay in Algiers, Renoir went back to Paris, and to Aline Charigat, whom he married. In 1882 he began in a number of paintings to develop a bolder line, and colour that heightens into subtle, pearly waves. He painted the three panels on the dancing theme – *Dancing at Bougival* (Museum of Fine Arts, Boston), *Dancing in the country* and *Dancing in the town* (Durand-Ruel Collection). Suzanne Valadon posed for the first two of these; she was also a model for Puvis de Chavannes.

Renoir was living through what he was to call his crisis. He kept himself more to himself, and strove yet harder for precision of line, trying to capture 'the smallest details' in the curving, flowing forms of Raphael and the Greeks. He even drew his figures first with a pen on the canvas. The result was paintings like *In the Luxembourg Garden* (*pls 36-7*) and *The umbrellas* (*pls 38-40*).

In April 1883 Durand-Ruel put on a Renoir exhibition in the Boulevard de la Madeleine, and even Pissarro, who was unhappy at that time with the 'crude and rough-looking' work Renoir was turning out, admired his *éclat*. In September of that year he went with Aline and Lhote to Guernsey and brought back landscapes depicting a smiling Arcadia. 'One has the feeling more of a Watteau landscape than of reality,' he wrote. What surprised him most was the way women bathers walked around so freely on the beach; to Renoir this seemed like some ancient free way of life worthy of a Greek setting. He saw in their bodies something immensely remote, something which, as he liked to say, had an element of the eternal. For some time, now, he had been in a state of doubt about his 'impressionism'.

In 1883 he happened on the medieval treatise *Libro dell'Arte*, by Cennino Cennini, translated into French by Victor Mottez, once a student of Ingres. Renoir read with admiration of the craftsmanship that was such a marvellous

element in the lives of the painters of antiquity. Now he strove to achieve well-balanced composition in more complex paintings such as *The children's afternoon at Wargemont*, painted in 1884 (Nationalgalerie, Berlin). But he also tended towards a greater variety of poses and expressions. His new emphasis on draughtsmanship made him realize afresh how rich, diverse and irregular is nature. Indeed he toyed with the idea of a ' Société des Irrégularistes ' and he put together notes for a grammar for young architects, which would show their keenness to escape from precise dimensions. ' He who studies the irregular must realize that a circle should never be round. ' Nature, he said, has a ' horror of regularity. ' Monet, for sure, did not approve.

Monet and Renoir together went to the Côte d'Azur in the winter of 1883, but Monet left again early in 1884 and wrote to Durand-Ruel asking him not to tell Renoir but he could no longer work with him because it would be ' disastrous for both of them. ' Renoir realized why Monet had left, and he was not at all upset; he had his work to get on with, and apart from a number of commissions for portraits, there was his new obsession for Ingres. Early in 1885, after the birth of his son Pierre, he rented a house at La Roche-Guyon on the Seine. And there, in the sunlit garden, he painted those pictures of motherhood which have such firm moulded clarity that they seem to echo some ancient Italian *maniera* or, as Pach remarked, the Fontainebleau school. It is enough to look at *Aline with her son* (1885, Gangnat collection, Paris; 1886, Chester Beatty collection, London) in which the use of tiny touches of colour is vaguely reminiscent of *pointillisme*. This also applies to *Cow-girl* (*pl. 42*), painted in 1887.

It was in the same year, 1887, that Renoir exhibited at the Galerie Georges Petit a painting he had been working on since 1884. This was the big *Bathers* (Tyson collection, Philadelphia). Preceded by numerous preparatory drawings, this painting cost him an enormous effort; but some people, including Huysmans and Astruc, disliked it and said that Renoir was making a serious mistake. Pissarro wrote to his son that there was no unity in the new Renoirs; perhaps they were good in parts, but overall there was something

wrong. Degas, always reticent, muttered: ' By dint of painting round figures, Renoir is making pots of flowers! ' Renoir's gaiety had disappeared. ' When Renoir is gay, something which is rare . . . ' said Edmond Maître. And even the drawings and paintings for Julie Manet and the *Blonde bather* in Oslo have that ' clear, pure line ' – as Van Gogh called it – which surrounds the figures in a lucent flexibility. At any rate, Renoir did not follow a set pattern even in his ' sour period ' (*manière aigre*), as he called it.

Renoir soon began making trips again into the provinces. He went with Cézanne to Jas de Bouffan, and with Aline to Martigues, where he did several watercolours. While Durand-Ruel was solving, with exhibitions in America, Renoir's financial problems, and was then in Paris paving the way for further successes for the impressionists, Renoir went back to Argenteuil. Berthe Morisot saw him late in 1888 and described him as ' not at all gloomy, very talkative and fairly pleased with his work. ' Now he had regained his original faith in nature and his own exuberance. He stayed again with Cézanne and in 1889 he painted *Mont Sainte-Victoire* (Barnes Foundation, Merion, Pa.) in which the vague influence of Cézanne, detectable in the unusually solid composition, is more than balanced by the mass of flowering almond trees in the foreground. He was emerging from what he was to call an *impasse* in both line and colour.

In the paintings he did around 1890 there is a fusion of his new technical innovations – the ripe, full-blown appearance of his women bathers, and the billowing transparent colours – with the slow splendid maturing of an observant, contemplative, domesticated Olympian. He was now almost fifty, and with the slightly cynical wisdom of his long and proven experience, he talked with the young artists at the Café du Rat Mort – Toulouse-Lautrec, Joyant and Anquetin. ' Get it into your heads that nobody knows a thing about it, not even me. ' To Anquetin's haughty protest he replied crossly: ' So you want to become the emperor of painting. Very well – except that there are no more emperors! ' He was scornful of Pissarro's faith in scientific formulas for painting. But he enjoyed the delightful com-

pany of Berthe Morisot, whether in Paris or at Mézy. And at home he liked listening to Mallarmé, for whom he had done an etching for the frontispiece of the collection of poems, *Pages*, published in Brussels.

Renoir did about fifty prints – etchings, drypoints and lithographs – and they have the same qualities of ' seductive charm and rare softness ' (Delteil) as do his paintings. In 1890 he took an apartment in Paris in the Château des Brouillards, near the Maquis, a suburb of trees and fields. It was a quiet corner, just right for Renoir who felt more and more a countryman. He liked now to spend long periods in the south, at Tamaris-sur-Mer, or at Lavandou. ' I soak up the sun, and some of it stays in my head . . . ' he wrote to Durand-Ruel. Again he began covering his canvases with extraordinarily limpid colour, while with every new painting he achieved a deeper *rapport* between nature and the figures he painted.

Magazines and newspapers began to take an interest in him. André Mellerio did a ' portrait ' of him in *L'Art dans les Deux Mondes* of 31 January 1891. Albert Aurier in the *Mercure de France* wrote of this Renoir, who, although convinced of the futility of life, of women and of the world, yet ' glorifies illusion '.

In May 1892 Durand-Ruel put on a one-man exhibition of one hundred and ten of Renoir's paintings, listed in a catalogue by Arsène Alexandre. It was a spectacular success. Meanwhile Renoir, in the bright light of southern villages, or on the coast, started painting a series of young women bathers (*pls 48-50*) in the fields, as well as landscapes, flowers and fruit. And in Paris he did the series of family scenes, which showed Gabrielle, Jean his second son born in 1894, the teenage and young children of his friends, and women friends who visited his house in Paris or at Essoyes; one of the best of these is *The artist's family* (1896, Barnes Foundation, Merion, Pa.).

The gardens and countryside of Berneval and Louveciennes are warm fragrant settings where the radiant bathers recline or move about. Renoir was still using outline to give his figures volume, as he said teasingly; but this is only a slow bold brush line, usually of brownish-red, which sketches in

the figures and gestures; then, with very diluted colours, *à l'essence*, he 'dabs swiftly at the canvas', as if he were doing a watercolour, and the colours are bound one with the other and something springs up 'that delights you before you even know what it represents.' Later on he used pure colours, not mixed beforehand on the palette – emerald green and cobalt blue, yellows and burning reds, and sometimes white and ivory black.

Again he used soft, golden flesh tones and tints of golden red and white in the series of paintings, *Gabrielle with jewels* (*pls 58-9*), *Gabrielle with rose* (*pl. 66*), *Girl combing her hair* (*La Toilette, pl. 57*), *Sleeping Odalisque*, 1915-17, and numerous other paintings which all reveal the knowledge of colour, as a living yet subtle force, which Renoir had acquired during his years of prolific maturity. The energy and exuberance that swept him along, even despite his paralysis, continued unabated. There were no rules or set methods for this flowering, vibrant painting. By now Renoir could perceive not only the individual character of whatever he was painting, but also the universal qualities of nature. 'I look at a nude. There are myriads of subtle tints.'

At the age of sixty, although he was often in pain, he took to sculpture, and with his own hands he made a profile and a bust of Claude, his youngest son; and some years later, with the help (under his supervision) of the young sculptor Richard Guino, he did *Washerwoman* and *Venus the victress*, 1915-16 (in the house at Cagnes), and the bas-relief of the *Judgment of Paris* (Werner & Bär collection, Zurich). In these Renoir gives his material the same plastic qualities as he did his painting.

Even in the apparent decline of some of his last pictures, where the vegetation seems to flake away, or the fleshy parts of flowers to break up into strips, or the flesh of the women bathers to billow and brim over, there is still that 'indescribable and inimitable' quality that he sought in painting. Ancient and yet modern, similar to and yet different from Monet, the last of the old group of friends who was still working vigorously at Giverny, Renoir had aimed to express in his work a direct outpouring of life

itself. 'A work of art,' he said, 'ought to catch hold of you, envelop you, carry you away.'

In all that Renoir said and wrote in those last years, there are more and more frequent references to the old masters and the great classics; nevertheless it is well to remember not only his special and open enthusiasm for the pictures in the great museums, but also the controversial position that, with Monet and Cézanne and Degas, he was conscious of occupying during the last decade of the nineteenth century and those early years of our own century which were so full of new movements and theories and intellectual experiments, from syntheticism to cubism. There were great names and movements, and earth-shaking rebellions, which, to Renoir, seemed to have no substance. He could still speak of tradition, rather than deny that it had any value, for his links with the ancient world were real and vital; never for a moment was he a slave to the past, but he could revitalize in contemporary terms the feelings and perceptions of the past. The infinite resources he had developed during a life-time's work were handed on to other great painters like Matisse and Bonnard, whose debt to Renoir is obvious and openly acknowledged.

Renoir's achievement is all the greater when one considers how every fragment he painted can shed light on the banal facts of human life. He had the immortal gift, as Proust put it, of arresting the passage of time in a single luminous instant.

Renoir and the Critics

There is a comment on Renoir's work in an article by William Bürger published in *Le Salon de 1868*. In 1874 Louis Leroy wrote in *Le Charivari* an article entitled '*Exposition des impressionistes*', and remarked that the *Dancer* (Washington) showed a lack of skill in drawing: 'The dancer's legs are as insubstantial as the gauze of her skirts.' Only an article by Philippe Burty, which appeared without his name to it in *La République française* of 25 April, spoke with any interest of the impressionists; and of Renoir

it said: 'He has a great future. The young dancer has an astonishing harmony. *Parisiennes* is not so good, but *The box*, especially in the light, is utterly convincing.' We know why Renoir's name did not figure among the other 'independents' mentioned by Giuseppe de Nittis in his letter to the *Giornale Artistico* in 1874; the Italian painter had taken part in the impressionists' first exhibition but his paintings appeared only at the inaugural preview, because Renoir, who was in charge of arrangements, forgot to put them in the exhibition proper.

In 1876, after Albert Wolff's acid comment in *Le Figaro* that Renoir's figures were 'a heap of decomposing flesh', there came a reply from the less dogmatic and more perceptive voice of Armand Silvestre, in *L'Opinion* of 2 April, who commented on Renoir's 'delicate and charming range of pinks'. Then, in 1878, Théodore Duret's *Les Peintres impressionistes* gave a brief introduction to the new style of painting, and included biographical notes on each painter. In the following year, for the first time, an Italian critic and art lover, Diego Martelli, called Renoir a 'very delicate artist' in the lecture he gave to the Circolo Filologico of Livorno, which was published in 1880 in Pisa, and reprinted in *Scritti d'Arte di Diego Martelli*, Sansoni, Florence 1952.

During the exhibition held at the American Art Gallery, New York, by Durand-Ruel in 1886 – which included thirty-eight of Renoir's paintings – the critic of *The Sun* wrote (11 April) that Renoir was a degenerate and dishonourable pupil of a man so wholesome, upright and well-intentioned as Gleyre. The critics of *Art Age* and *The Critic*, on the other hand, praised his painting. In that same year Teodor de Wyzewa, a friend of Mallarmé and the Symbolists, wrote a full-scale eulogy of Renoir in the *Revue indépendante*.

Towards the turn of the century, newspapers and magazines began to take an ever greater interest in his work. Here are some of the articles and monographs devoted to Renoir:

J. Meier-Graefe, *Renoir*, Munich 1911; W. Pach, 'Inter-

view with Renoir ', in *Scribner's Magazine*, 1912 (reprinted in *Queer Thing, Painting*, New York 1938); O. Mirbeau, *Renoir*, Paris 1913, with extracts from articles by Wolff, Burty, Castagnary, Huysmans, Geffroy, Signac, Denis,. Bonnard, etc.; A. Vollard, *Renoir*, Paris 1918; J. - É. Blanche, *Propos de peintres, de David à Degas*, Paris 1919; F. Fénéon, ' Les Derniers moments de Renoir ', in *Le Bulletin de la vie artistique*, 15 December 1919; G. Besson, ' Renoir à Cagnes ', in *Les Cahiers d'Aujourd'hui*, November 1920; A. Tabarant, ' Le peintre Caillebotte et sa collection ', in *Le Bulletin de la vie artistique*, 1 August 1921: G. Rivière, *Renoir et ses amis*, Paris 1921; A. André, *Renoir*, Paris 1923; W. George, ' L'Œuvre sculpté de Renoir ', in *L'Amour de l'art*, November 1924; C. Roger-Marx, *Renoir*, Paris 1933; A. André and M. Elder, *L'atelier de Renoir*, Paris 1931; T. Duret, *Renoir*, New York 1937; M. Florisoone, *Renoir*, Paris 1937; L. Venturi, *Les Archives de l'impressionisme*, Paris and New York 1939; G. Bazin, *Renoir*, Paris 1941; J. Rewald, *Renoir Drawings*, New York 1946; P. Haesaert, *Renoir sculpteur*, Brussels 1947; C. Renoir, *Souvenirs de mon Père*, Paris 1948; M. Raynal, *Renoir*, Geneva 1949; J. Rewald, *The History of Impressionism*, new edn, New York 1962; J. Baudot, *Renoir, ses amis, ses modèles*, Paris 1951; F. Nemitz, *Auguste Renoir*, Cologne 1952; W. Gaunt, *Renoir*, London 1953; D. Rouart, *Renoir*, Geneva 1954; M. Drucker, *Renoir*, Paris 1955; D. Cooper, ' Renoir, Lise and the Le Cœur Family; A Study of Renoir's Early Development ', in *Burlington Magazine*, May and September-October 1959; W. Pach, *Renoir*, Milan 1960; F. Fosca, *Renoir, his Life and Work*, London and New York 1961; J. Renoir, *Renoir*, Paris 1962; F. Daulte, *Renoir*, Paris 1963; C. Hayes, *Renoir*, Paris 1963; H. Perruchot, *La Vie de Renoir*, Paris 1964; B. F. Schneider, *Renoir*, Milan 1964.

In preparation is the complete catalogue of Renoir's work, under the supervision of François Daulte; it will be in three volumes. The first volume will have reproductions of 2400 portraits and nudes, the second volume reproductions of the landscapes, and the third the still-lifes.

Notes on the Plates

1 Portrait of William Sisley, 1864. 81×66 cm. Paris, Louvre. Signed and dated. This is the father of the painter Alfred Sisley who was a friend of Renoir's from their student days at Charles Gleyre's studio. The portrait has a realism reminiscent of Courbet, but there is already a quality of light that derives from Manet.

2-4 Diana, 1867. 195×130 cm. Washington, D.C., National Gallery of Art, Chester Dale collection. Rejected by the 1867 Salon. Renoir was to say later that he wanted simply to do a nude study, but that he then added mythical trappings so that the painting would not be considered indecent, and because he hoped that decked out in the academic manner it would be accepted by the Salon.

5 Portrait of Frédéric Bazille, 1867. 105×74 cm. Paris, Louvre. Signed and dated. At the time Renoir was sharing Bazille's studio in the Rue Visconti, Paris. Manet liked this painting, and Renoir made him a present of it. It went to the Louvre in 1929 from the Musée du Luxembourg to which it had been donated in 1924 by Marc Bazille.

6-7 Barges on the Seine, c. 1869. 46×64 cm. Paris, Louvre. Signed. Shortly before he captured the intense play of light in the La Grenouillère landscapes, Renoir went back to big open scenes bathed in clear light. He persisted in painting high towering skies in the style of Jongkind, and with the gentle atmospheric quality loved by his friend Sisley.

8 Portrait of Mme Monet, c. 1874. 53×71 cm. Lisbon, Gulbenkian Foundation. In this period Renoir often visited Monet at Argenteuil, and he portrayed his friend in several pictures, as well as Monet's wife, Camille.

Dancer, 1874 (black and white illustration on p. 19). 142×94 cm. Washington, D.C., National Gallery of Art, Widener collection.

9 Portrait of Charles Le Coeur, 1874. 41×28 cm. Paris, Louvre. Signed. Charles-Clément Le Coeur (1830-1904), brother of Jules Le Coeur's father and a friend who was a model for many early Renoir paintings, was an architect and can be considered Renoir's first patron. Early in 1868 he arranged for Renoir to decorate two ceilings in the Paris house of Prince Bibesco – a house built by Le Coeur himself.

10-11 The box, 1874. 80×64 cm. London, Courtauld Institute. Signed and dated. It was shown at the impressionists' first exhibition

in 1874, and there are several versions: a larger one, dated 1876, was in the Robert Treat Paine collection in Boston; another is in the Georges Viau collection in Paris; a small study (27×22 cm.) for this painting, and differing from it in a number of respects, was in the Jean Dolfuss collection in Paris. In 1921 Picasso was inspired by this ' slice of life' in designing scenery for the ballet *Cuadro Flamenco*.

12 Path through the wood, c. 1874. 66×55 cm. Coppet, Switzerland, private collection. Signed.

13 Portrait of Claude Monet, 1875. 84×60 cm. Paris, Louvre. Signed and dated. Renoir several times painted his friend Monet, beside his easel, or in the garden of the Argenteuil house, or reading indoors.

14-15 Path climbing through long grass, c. 1874. 59×74 cm. Paris, Louvre. Its date is uncertain (Rouart and F. Fosca give 1874, and G. Bazin 1876-8), but it was painted in the Paris area, and stands as a remarkably powerful evocation of summer.

16 Young woman with a veil, 1875-7. 61×51 cm. Paris, Louvre. Signed. Scholars have ascribed to it various dates (G Bazin 1875-7, and Schneider 1880). It shows an exquisite feminine figure that emerges firmly from the play of light and a network of tiny brushstrokes that bind together the spotted veil, the black and pale yellow plaid material, and the blue-green background.

Lovers, c. 1875 (black and white illustration on p. 35). 175.5×130 cm. Prague, Narodni galerie, Sternherk Palace. Signed.

17-18 The first outing, 1875-6. 65×50 cm. London, National Gallery (Courtauld Foundation). Signed. Painted in Paris and usually known under the French title *La Première Sortie*, this picture has also been called *Café-Concert*. In its free open style it resembles *Moulin de la Galette* and *The swing*.

19 Woman reading, c. 1876. 47×38 cm. Paris, Louvre. Signed.

20 Nude in the sunlight, 1875-6. 80×64 cm. Paris, Louvre. Signed. This picture was bought from Renoir by Gustave Caillebotte and was left to the Musée du Luxembourg in 1896; it went to the Louvre in 1929.

21 The swing, 1876. 92×73 cm. Paris, Louvre. Signed and dated. This was another picture bequeathed by Caillebotte (see note to *pl. 20*).

22-5 Moulin de la Galette, 1876. 131×175 cm. Paris, Louvre. Signed and dated. With the help of friends, Rivière among them, Renoir moved his canvas to this Montmartre dance-hall so that he

could paint from life. In the picture are Franc-Lamy, Rivière and Goéneutte - seated at the table with glasses of *grenadine* - and among the dancers are Cordey, Lestringuez and Lhote. The young girl sitting on the bench in the foreground is Estelle, a sister of Jeanne. A replica on a smaller scale, from the Chocquet collection, is now in a private collection in New York.

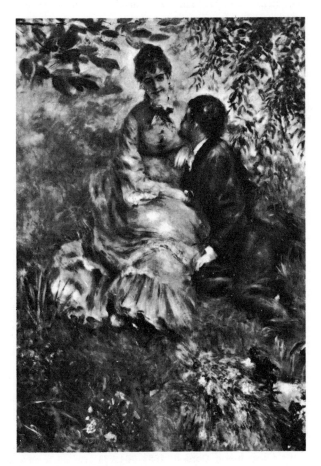

Lovers (see p. 34)

26 Portrait of Mme Henriot, c. 1877. 70×55 cm. Washington, D.C., National Gallery of Art. Signed. Here we see the same glowing luminosity of colour as in the eighteenth-century painters Fragonard and Watteau.

27 Portrait of Mme Georges Charpentier, 1876-7. 45×38 cm. Paris, Louvre. Signed. This is the wife of the publisher of Zola and Daudet. She ran the magazine *La Vie moderne*, and entertained intellectuals. Renoir sent her numerous letters when on his travels.

28-9 The Charpentier family, 1878. 153×169 cm. New York, Metropolitan Museum. Signed. Mme Charpentier appears here in her Japanese room with her two little girls. Renoir valued the friendship and patronage of the Charpentiers, and spoke of Mme Charpentier's ' inexhaustible goodness '. In several letters to her he signed himself ' your painter-in-ordinary '. At the 1879 Salon Georges Charpentier arranged for the painting to be hung in the centre of a wall where it got plenty of light, thus helping to ensure its success with the public.

30 Portrait of a model, 1876-8. 46×38 cm. Paris, Louvre. Signed. Manet's influence is evident here in the more rapid brushstrokes; it adds force to the bright frothy atmosphere conjured up by Renoir.

31 On the terrace, 1879. 61×50 cm. Chicago, Art Institute of Chicago, Lewis L. Coburn collection. Perhaps painted in the garden of the Rue Cortot, the composition is dense with colour and gives a foretaste of the relaxed, dreamy *Luncheon of the boating party*, now in Washington, and painted in the summer of 1881.

32 At La Grenouillère, 1879. 72.5×92 cm. Paris, Louvre. Signed and dated. Here at the *guinguette*, the popular inn, at La Grenouillère on the island of Chatou, frequented by trippers and boating parties, Renoir captures a moment of carefree enjoyment in the sun.

33 Pheasant in the snow, 1879. 49×64 cm. Geneva, A. M. and Mme L. C. Stein collection. Signed. In the spring of 1879, Renoir was introduced by Deudon, one of the first collectors to buy his work, to Paul Bérard, an embassy secretary. This was one of the still-lifes that Renoir painted in Bérard's *château* at Wargemont.

34 Little girl with blue ribbon, 1881. 40×35 cm. Lausanne, private collection. Signed and dated.

35 Young Algerian woman, 1881. Boston, Art Institute.

36-7 In the Luxembourg Garden, 1883. 64×53 cm. Lausanne, private collection. Signed.

38-40 The umbrellas, c. 1884. 184×115 cm. London, National Gallery, Lane Bequest. The date of this picture is disputed because of the detailed technical differences in the painting; but its overall design suggests it was painted when Renoir was particularly concerned with form, the so-called ' sour ' or Ingres period. The figure on the left is already close to the severe lines of the big *Bathers* (1884-87), in the Tyson Collection in Philadelphia, and of *Girl plaiting her hair* (1886), now in a private Swiss collection.

41-2 Cow-girl, 1887. 54×65 cm. Geneva, private collection. Signed. Renoir was still laying great stress on line, and there are echoes here of his enthusiasm for Raphael, for Ingres, and for the clear-cut lines of the eighteenth century. He did a sketch in oils for this painting, which is now in the Stanley W. Sykes collection in Cambridge, Mass., and also a preliminary drawing which is in the Durand-Ruel collection, Paris. The painting once belonged to the Jacques-Émile Blanche collection.

43 Young girl with flower basket, 1888. 81×65 cm. Lausanne, private collection. Signed. There are two sketches in oils for this soft, elegant painting; they are in a private collection in London. The painting was bought from Renoir by Durand-Ruel in 1890.

44 Moss roses, c. 1890. 35×27 cm. Paris, Louvre. Signed. The roses seem to be frothing out of the vase; they seize possession of the canvas. To the dealer Vollard, who was amazed to see him painting roses, Renoir said: ' It's some research I'm doing into flesh tints for my nudes '. The painting was left to the Louvre in 1941 by Paul Jamont.

45 Two little girls at the piano, 1892. New York, private collection. The tonal quality and construction have a severity which is again reminiscent of the Ingres period, but as always the play of light and the delicate colour harmonies give a painting that is in the ' gentle and light ' style to which Renoir returned completely after 1890. There are five variations of this admirable picture, all painted during the same period.

46 Young bather, 1892. New York, private collection. One of the most intense of late nineteenth-century paintings. The structure of the body is all the more subtle and unified through its juxtaposition with the delicate foliage of the hedge.

47 Girl in green reading, 1894. 25×20 cm. Paris, Louvre. Signed. This is an example of the bold, sweeping technique by which Renoir — and this is borne out by artists and critics who saw him at work — achieved the main character of a picture with broad streaks of pure colour.

48 Standing bather, 1896. 81×60 cm. Fribourg, private collection. Dedicated to Baron Chollet. Signed and dated.

49-50 Two bathers, 1896. 34×41 cm. Coppet, Switzerland, private collection. Signed. Probably painted at Beaulieu-sur-Mer, where Renoir spent the summer of 1896 and where he did several pictures of women bathers in repose or moving about the sunny beach.

51-2 Woman in straw hat, c. 1897. Lausanne, private collection. Dedicated to Mme George Bigar. This painting announces the full colour harmony and luminosity of Renoir's final period.

53 Nude in an armchair, 1895-1900. Zurich, Kunsthaus.

54 Nude in a landscape, c. 1905. 65×52 cm. Paris, Orangerie. Exceptional vitality and opulent colour, reminiscent almost of the Venetian masters of the sixteenth century, give this figure of a woman bather a timeless quality.

55 Portrait of Ambroise Vollard, 1908. 81×64 cm. London, Courtauld Institute. Signed and dated. Vollard was the dealer with the famous cellar in the Rue Laffitte in Paris, who bought Renoir's pictures and later wrote his memoirs of the artist. Renoir gave this picture to Vollard, and it was acquired by Samuel Courtauld in 1927.

56 The red clown, 1909. 120×88 cm. Paris, Orangerie. Signed and dated. It was Claude. Renoir's third son born in 1901, who posed for this painting.

57 Girl combing her hair, c. 1910. 55×46 cm. Paris, Louvre. Signed. Painted at Cagnes, this is another subject that often featured in Renoir's final period. This painting, known as *La Toilette*, came from the Camondo collection; it went to the Louvre in 1911, and was put on show in 1914.

58-9 Gabrielle with jewels, 1910. 81×66 cm. Geneva, private collection. Dedicated to M. Albert Skira. Signed. This picture reminds us of what Renoir used to say of Velázquez's painting, which fascinated him: 'With a thin wash of black and white. Velázquez manages to give us thick, heavy flourishes ... the whole art of painting is in that'!

60 Coco and two maidservants, 1910. 65×54 cm. Paris, Gangnat collection. Signed. Also called *Women in hats*. it features his son Claude, also known as Coco, born in 1901.

61-2 Reclining nude, c. 1910. 67×160 cm. Paris, Orangerie. Renoir's model and housekeeper, Gabrielle, appears here and in numerous paintings done between 1900 and 1915.

63-4 Nude woman seen from the back, c. 1909. 41×52 cm. Paris, Louvre. Signed. In Renoir's paintings the Venuses of the Renaissance reappear, painted in a more rapid, flowing style.

65 House at Cagnes, c. 1910. Paris, Galerie Bénézit. Signed.

66 Gabrielle with rose, 1911. 55×46 cm. Paris, Louvre. Signed and dated. On the back of the canvas are the words 'Cagnes 1911'. Gabrielle came to the Renoir household in 1894 and was the artist's servant and model for many years. This painting was donated to the Louvre by Philippe Gangnat before the sale of his collection in 1925.

67-8 Tree by a farmhouse, 1912. Paris. Gangnat collection. Signed.

69 Portrait of the poetess Alice Vallière-Merzbach, 1913. Geneva, Ghez collection. Signed and dated. The need to give this portrait an almost official character results in a certain severity in the composition. But though the figure of the woman dominates the painting, there is a free treatment of the silky dress and the bunch of flowers on the console.

70 Mother with child. Edinburgh, National Gallery of Scotland. Signed. Renoir's three sons, Pierre, Jean and Claude, often served as his models when being nursed as babies by his wife Aline. There are numerous pastels and drawings on this theme, to which he returned also in his later years.

71 Roses in a vase, c. 1917-19. 29×33 cm. Paris, Louvre. Signed. This painting points the way to some other splendid bunches of roses that Renoir painted between 1917 and 1919.

72 Gabrielle in big hat. 55×37 cm. Grenoble, Musée des Beaux-Arts. Signed. After Mme Renoir died, Gabrielle took over the running of the house and also posed for the artist.

73 Walk along the beach. Milan. Galleria d'Arte Moderna. Signed. A late work in which the landscape is now only a burning symbol of creation.

74-5 Girl before a mirror. 60×47 cm. Rouen, Musée des Beaux-Arts. Signed. From the Vaumousse bequest, this picture went to the Rouen museum in 1954.

76 Milkmaid. 35×31 cm. Grenoble. Musée des Beaux-Arts. Signed. One of his last paintings. It may have been touched up several times till it was encrusted in a sea of colour that overlies the primitive rustic character of its subject.

77-8 Bathers, c. 1918. 110×160 cm. Paris, Louvre. Painted at Cagnes. Renoir probably used for this picture Dedée, a young model who posed for him for several years and was to become the wife of his son Jean, the film director. This great picture contains the

very essence of Renoir's art, expressed in his favourite theme of bathers resplendent in summer light. It follows on from the marvellous pictures and sculptures of the last years – the *Judgment of Paris*, the *Concerts* (*Girls with Mandoline*) – on which the artist still worked energetically till the end of his life. This painting was exhibited at the Venice Biennale in 1948.

79-80 Woman leaning, c. 1919. 23×32 cm. Paris, Orangerie. Signed. The colours of Renoir's last paintings suggest that he was searching for a synthesis of his whole painting technique and his deep feeling for nature. One of the last things he said was: ' I think I'm beginning to understand something of what it's all about '. And till the day he died, he was always asking for a pencil and paper so that he could set down some aspect of nature.

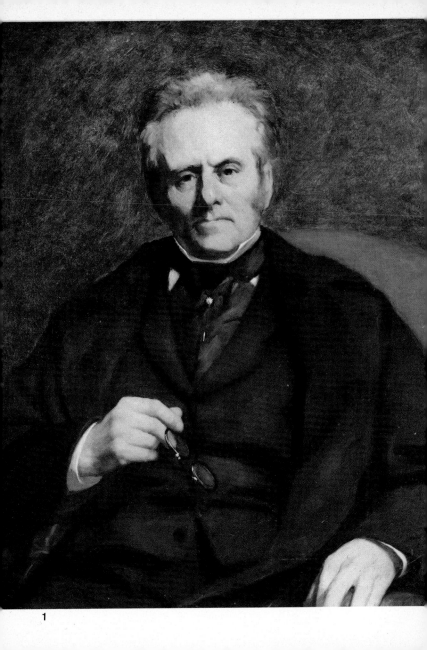

1

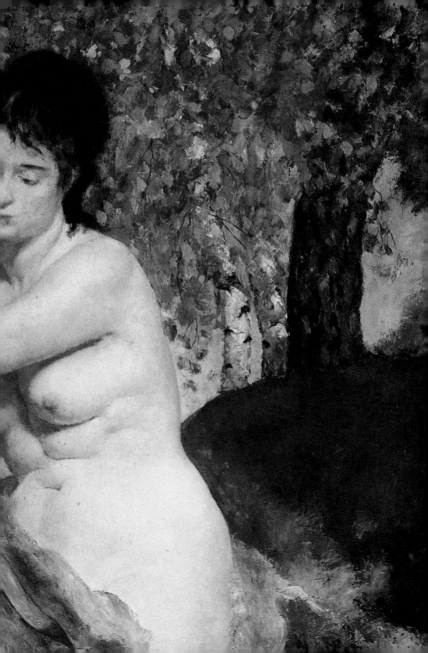

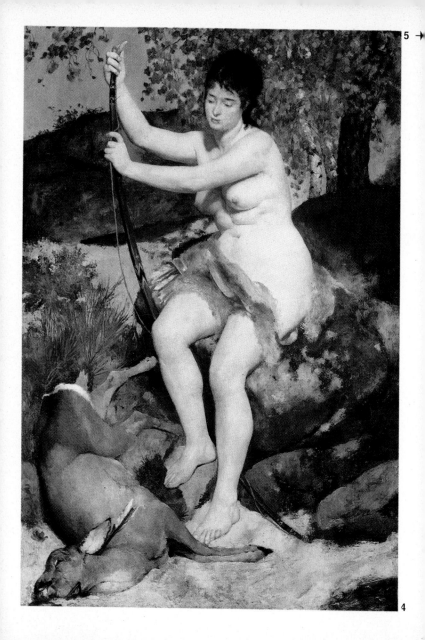

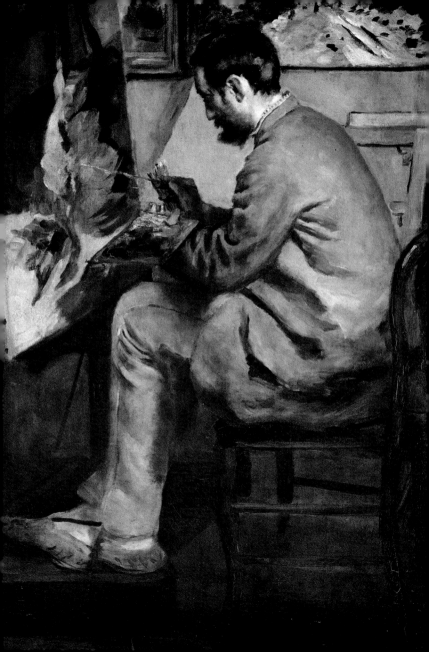

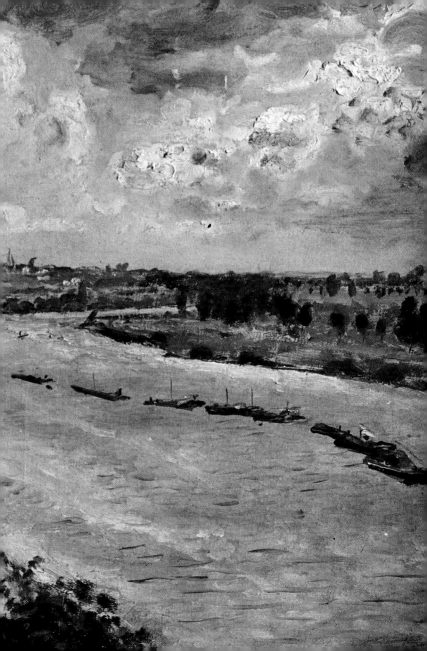

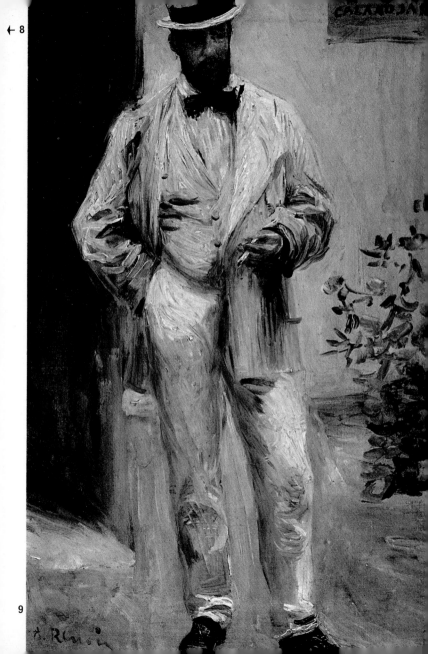

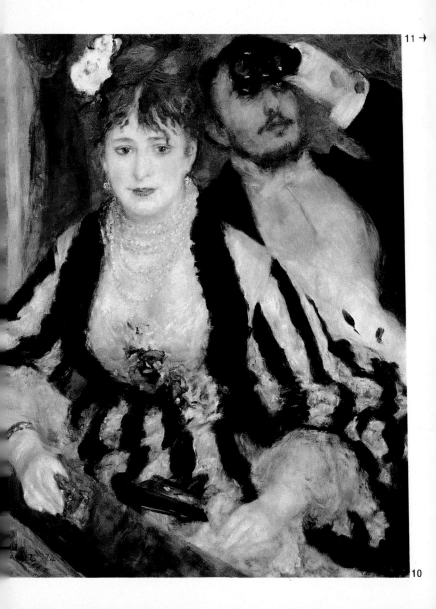

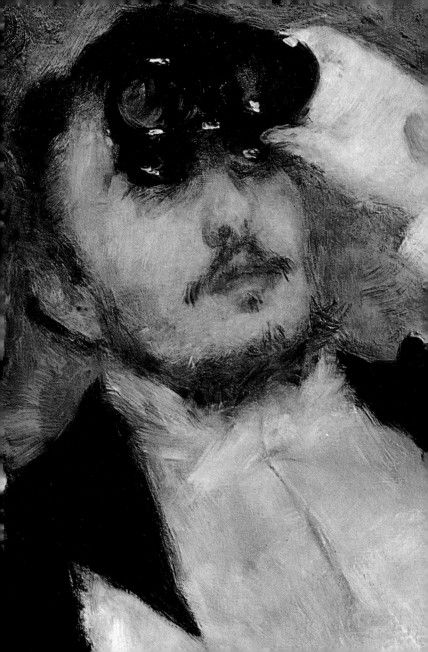

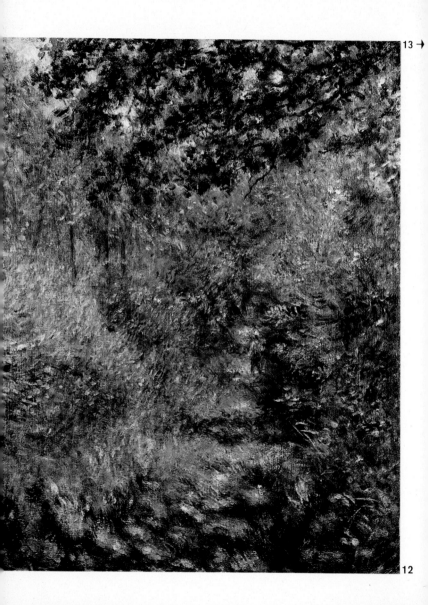

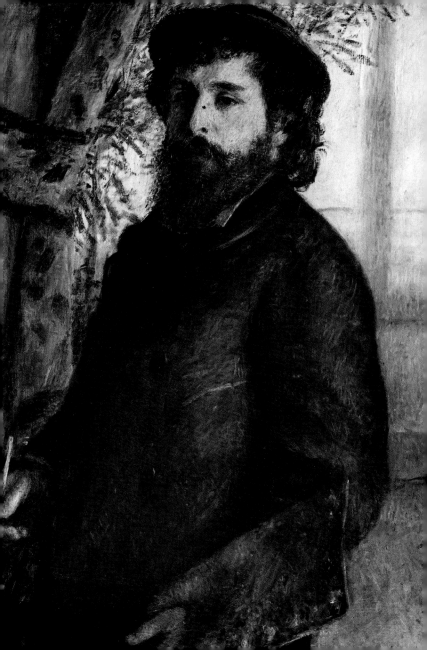

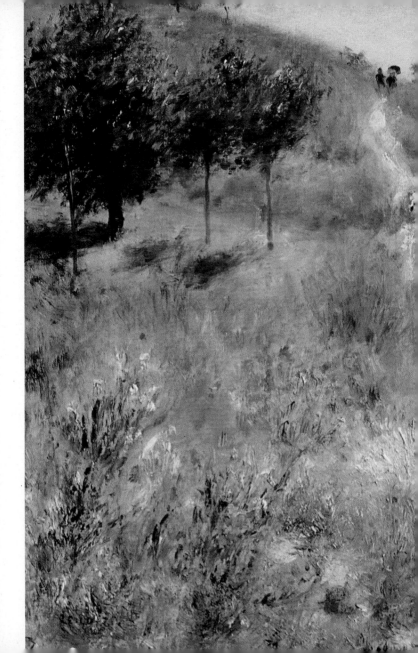

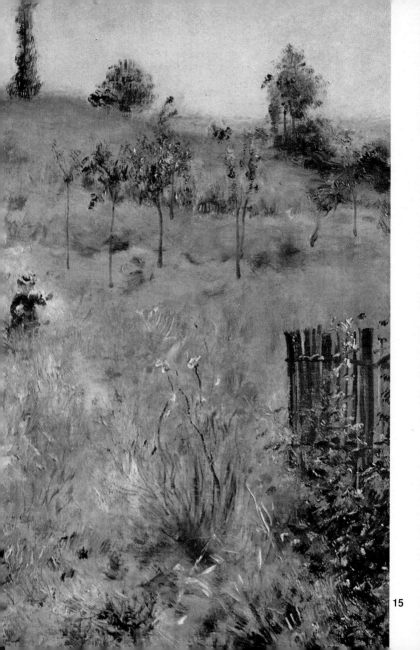

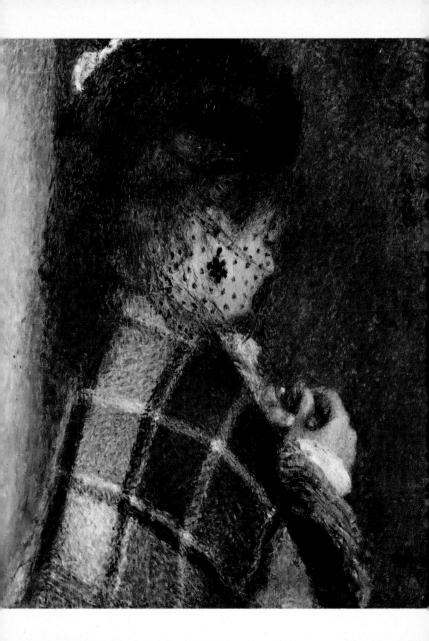

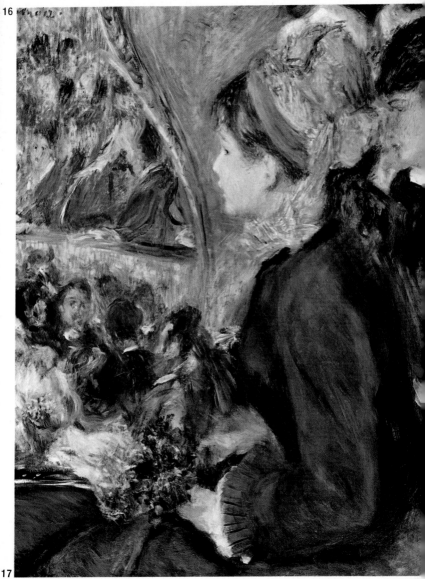

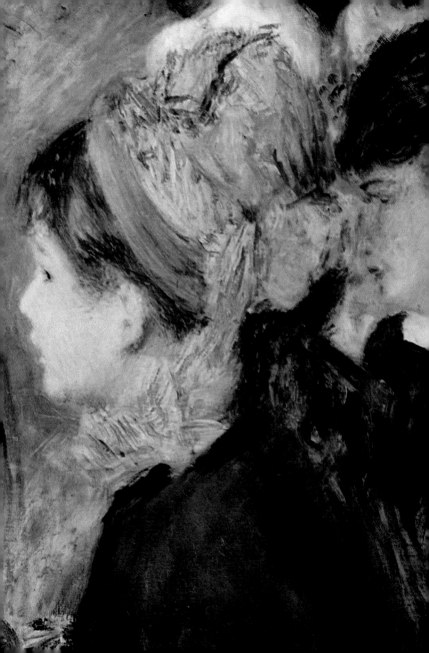

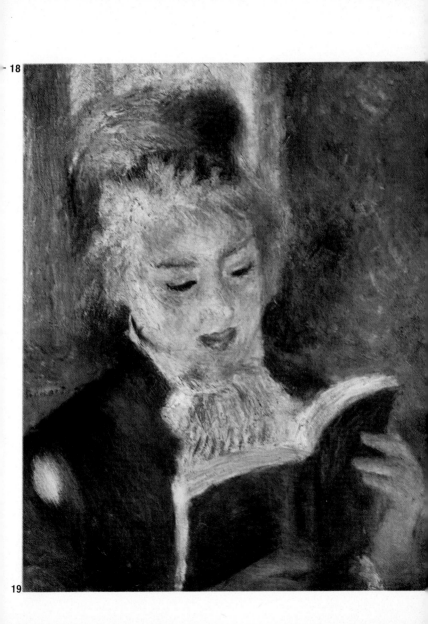

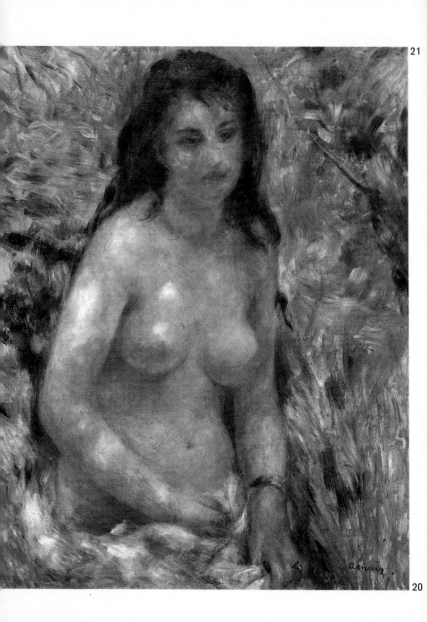

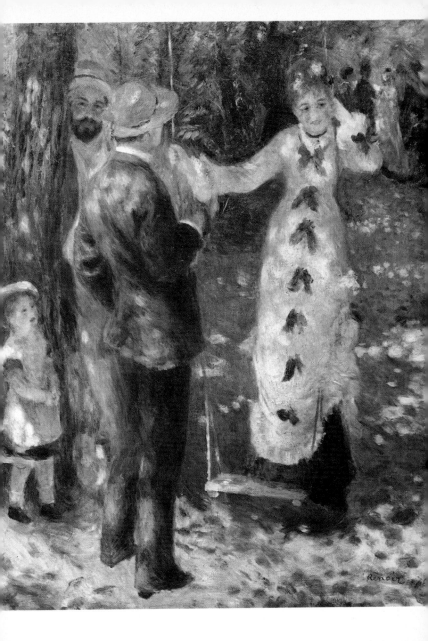

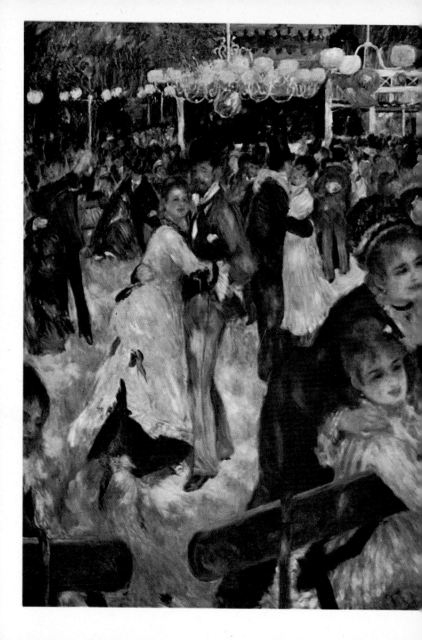

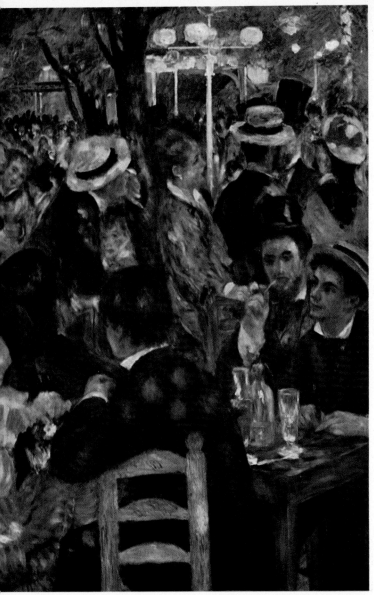

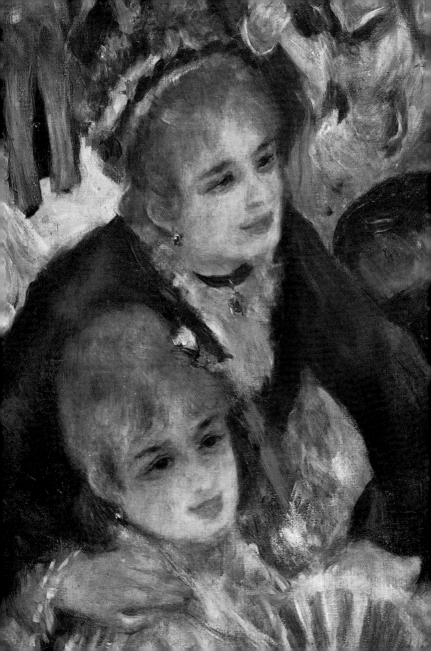

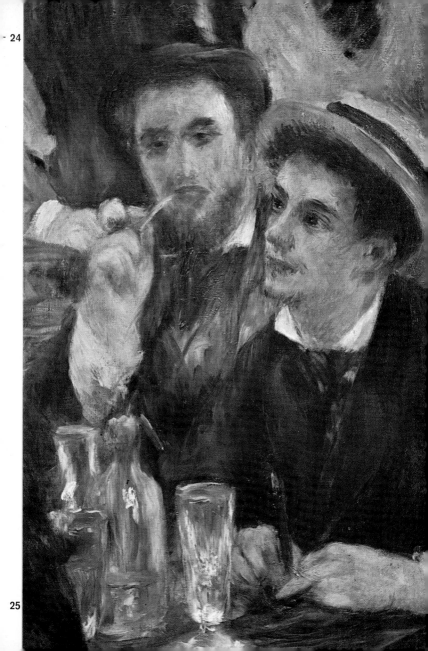

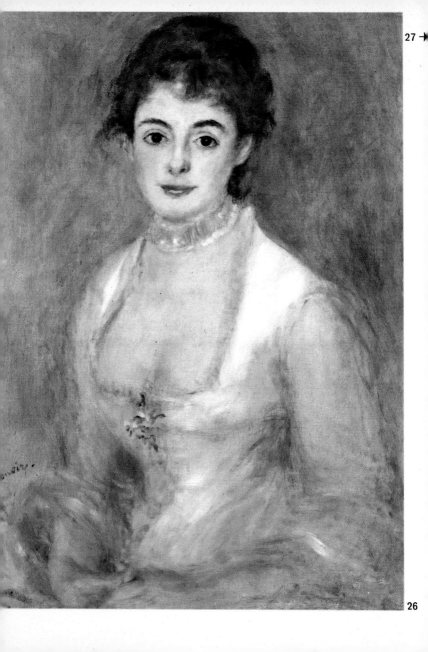

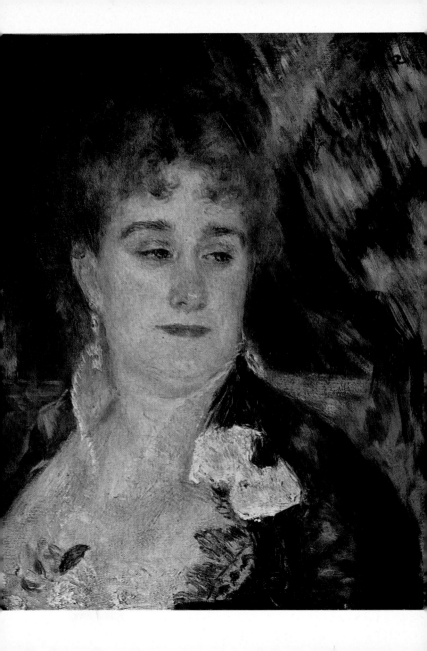

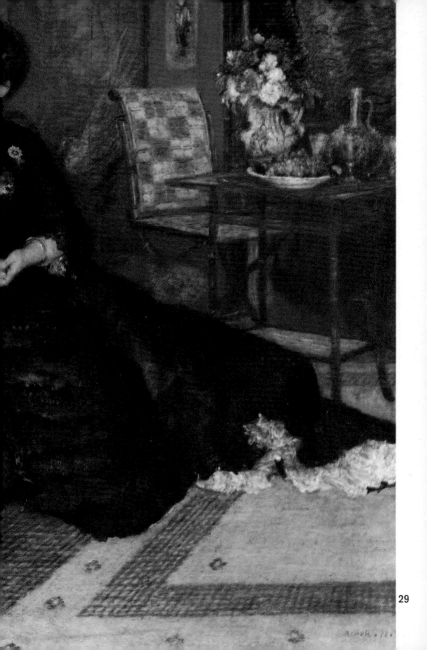

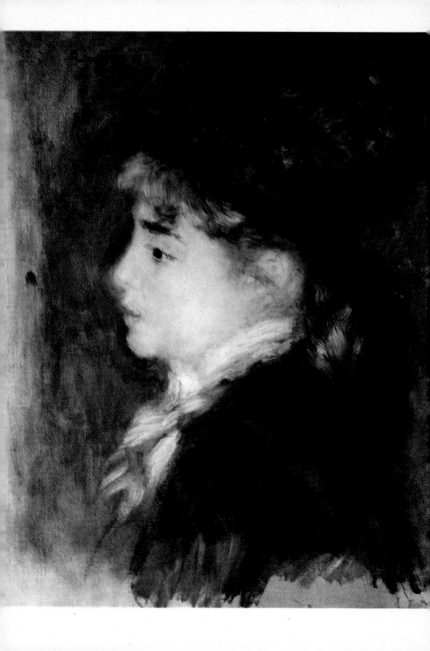

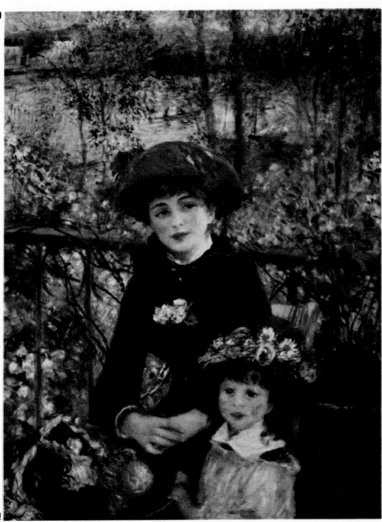

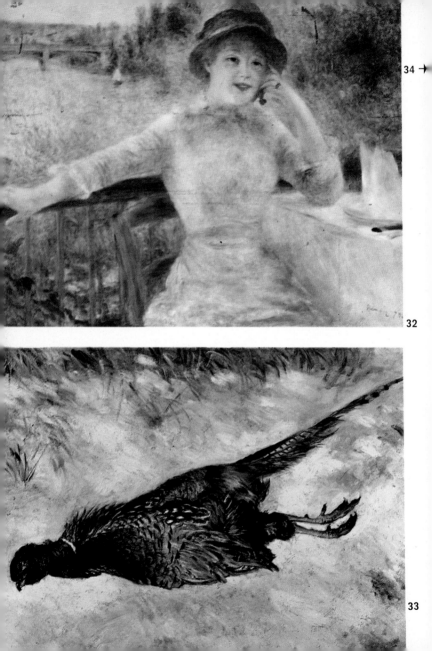

34 →

32

33

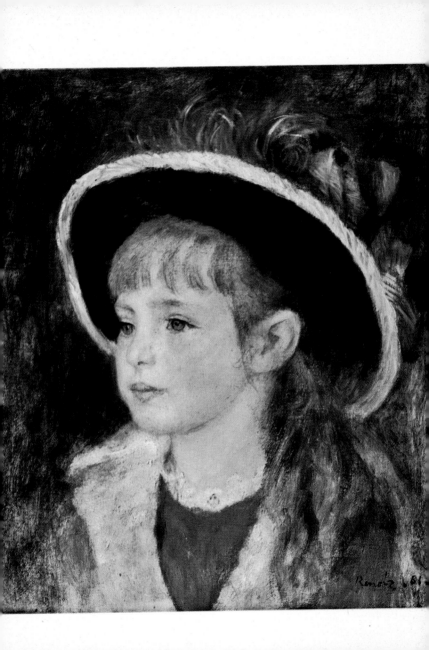

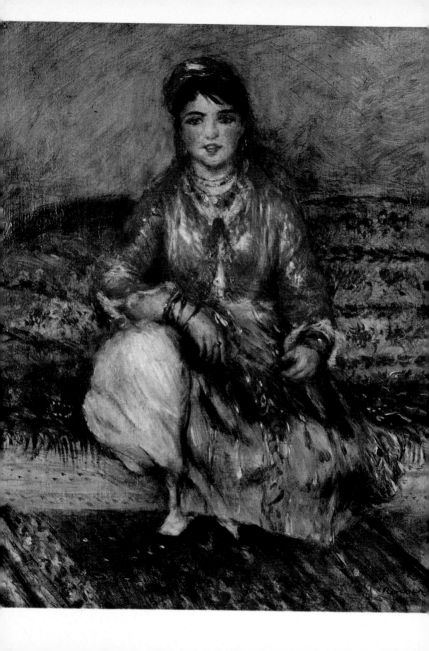

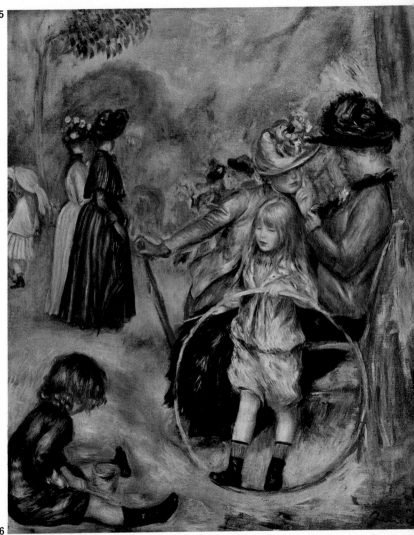

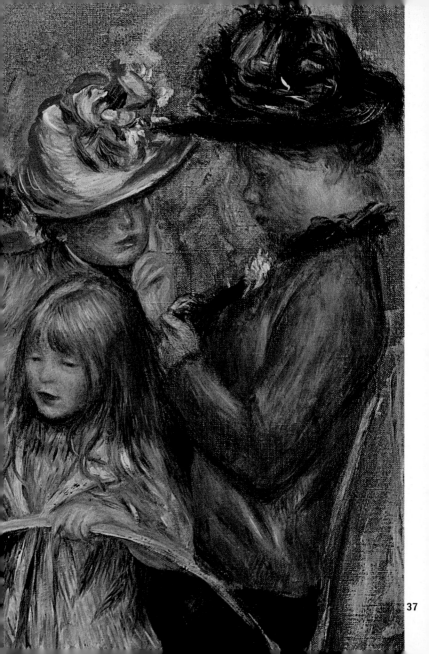

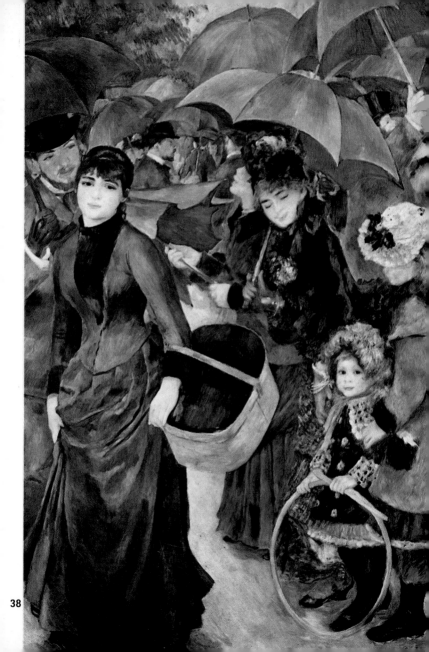

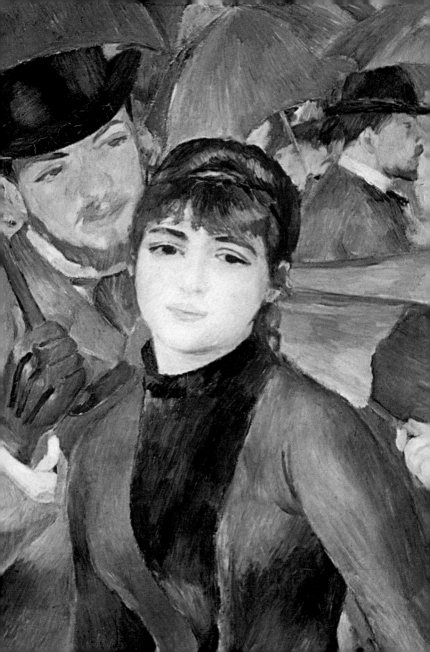

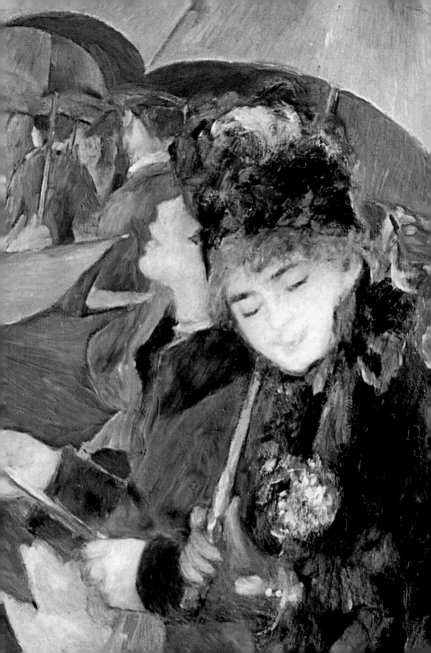

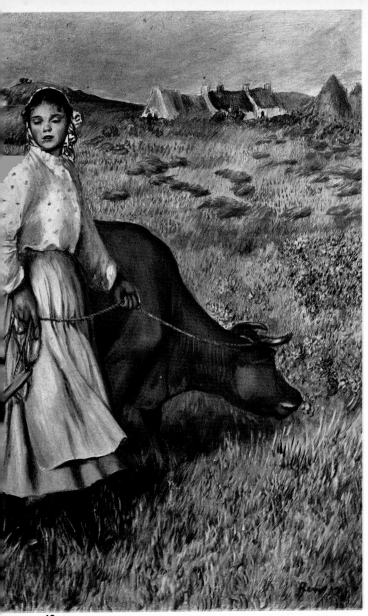

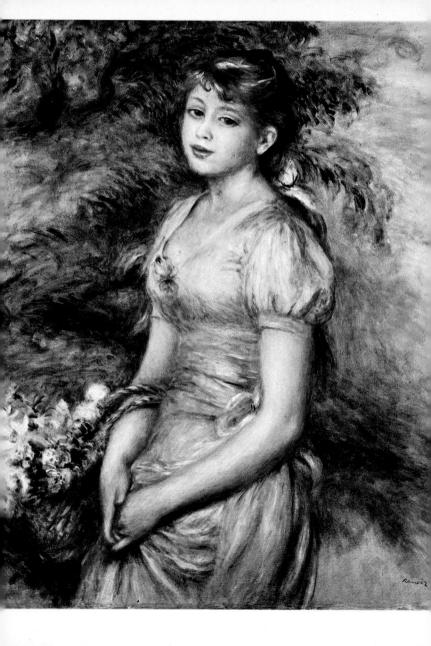

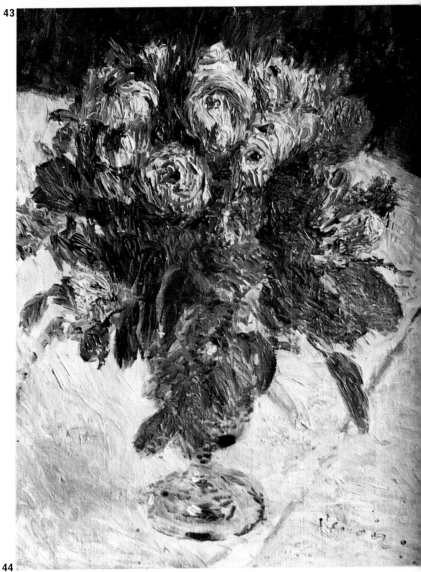

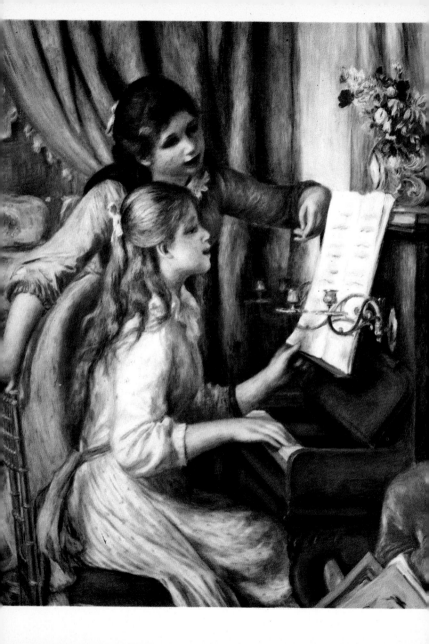

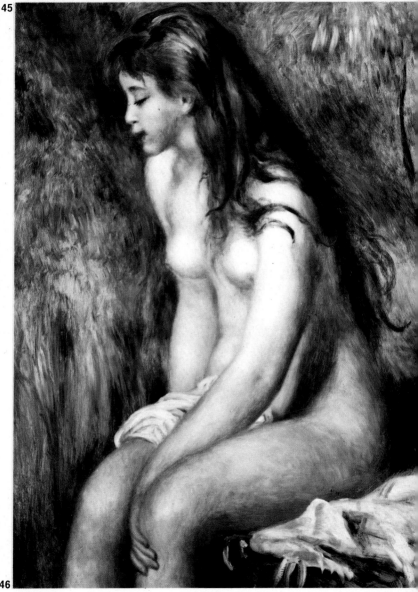

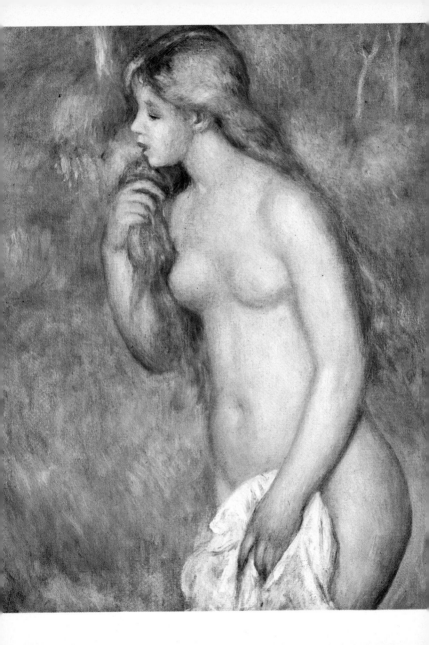

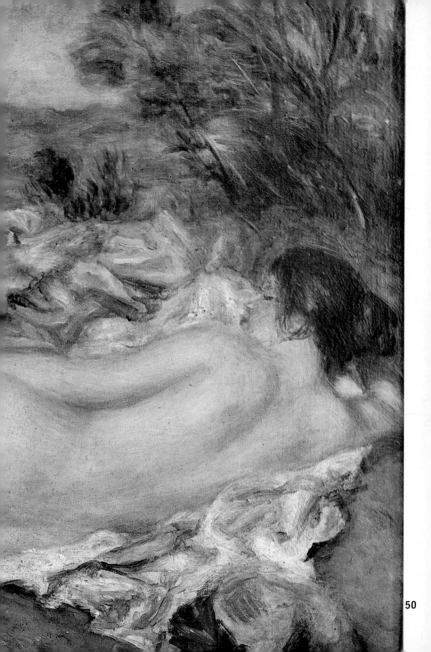

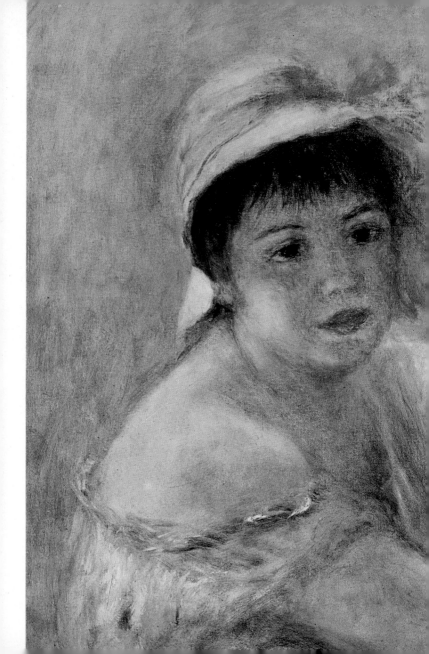

52

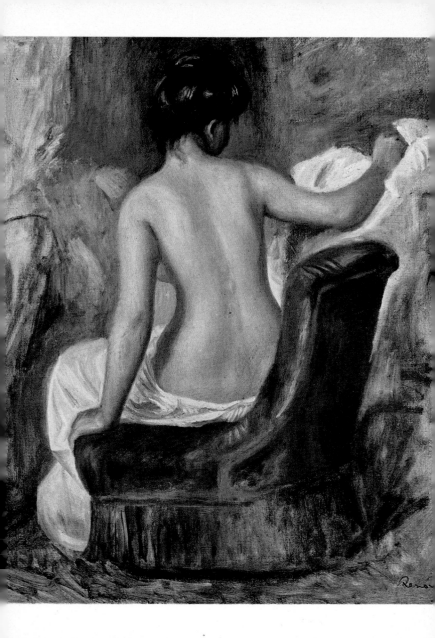

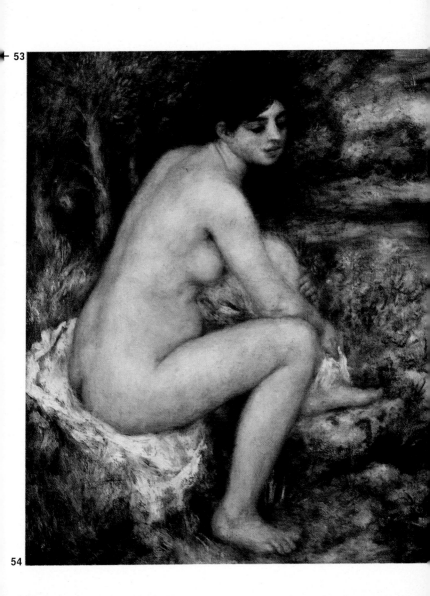

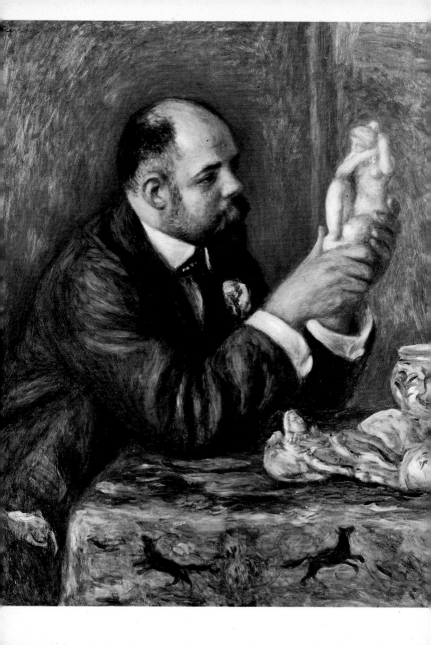

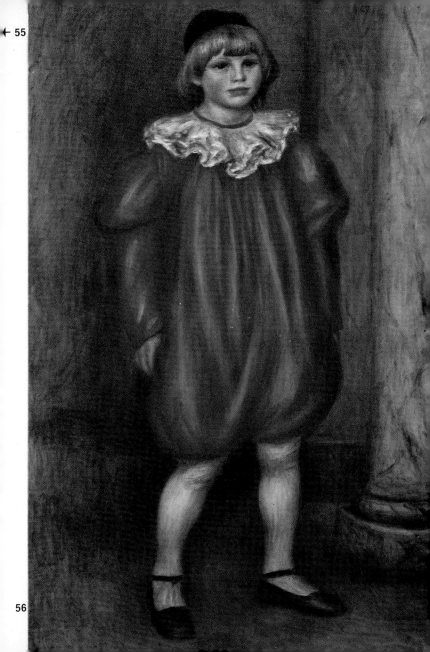

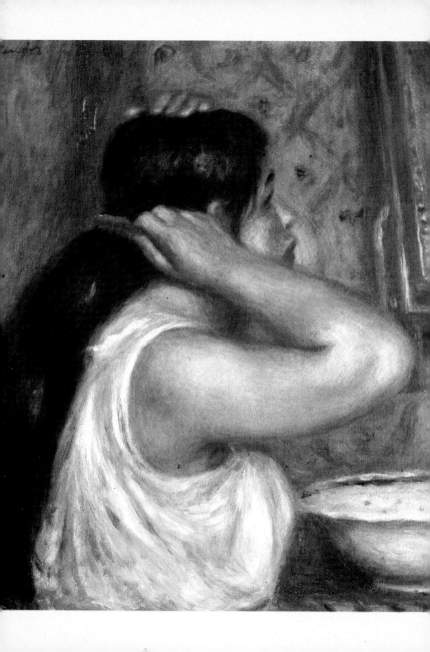

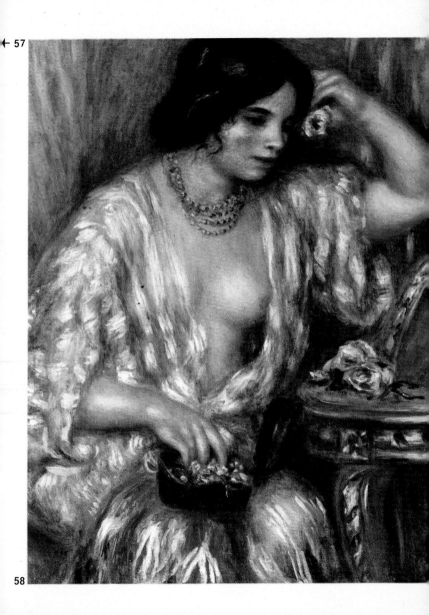

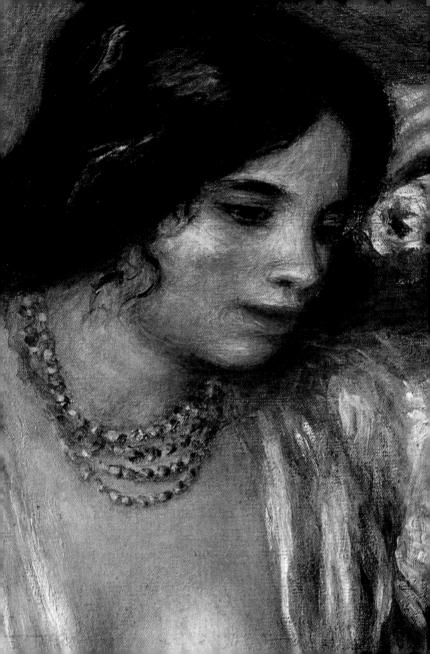

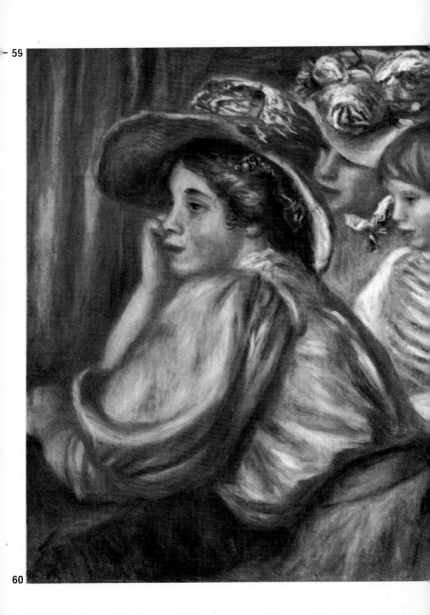

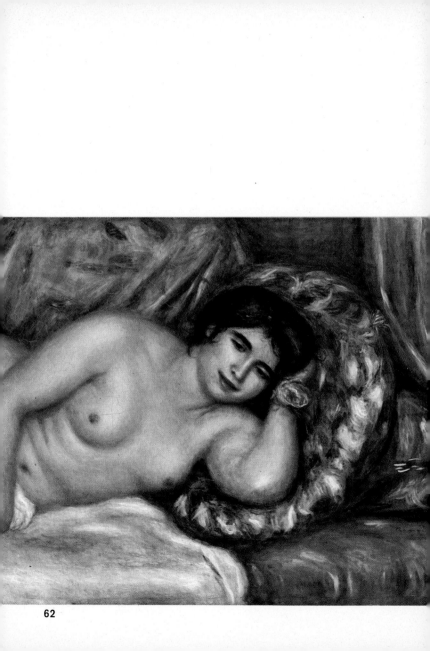

64

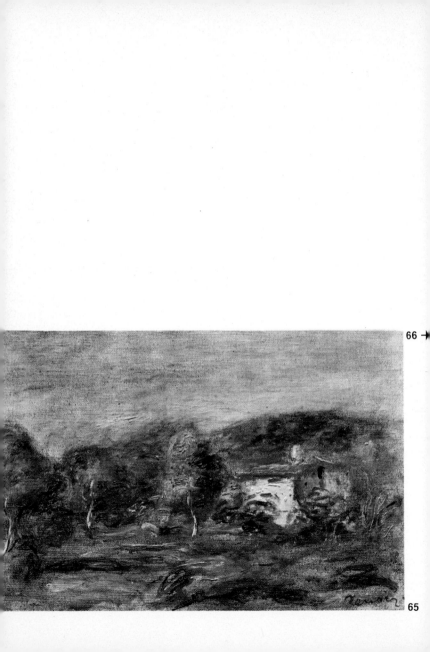

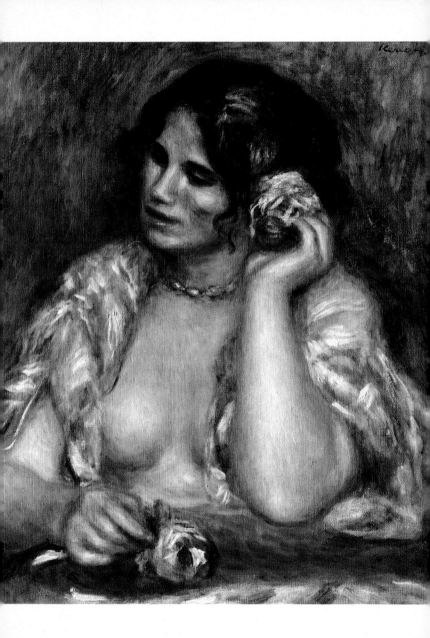

68

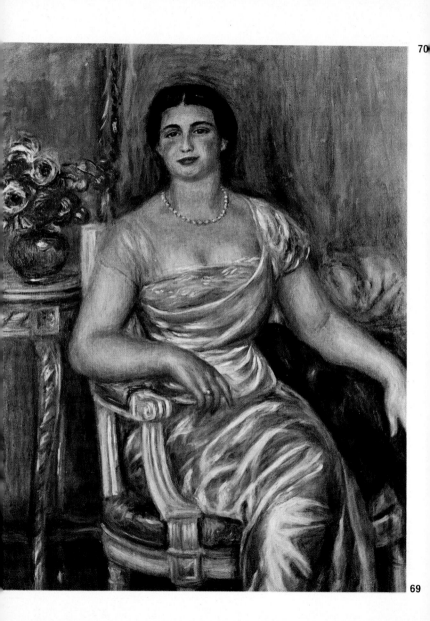

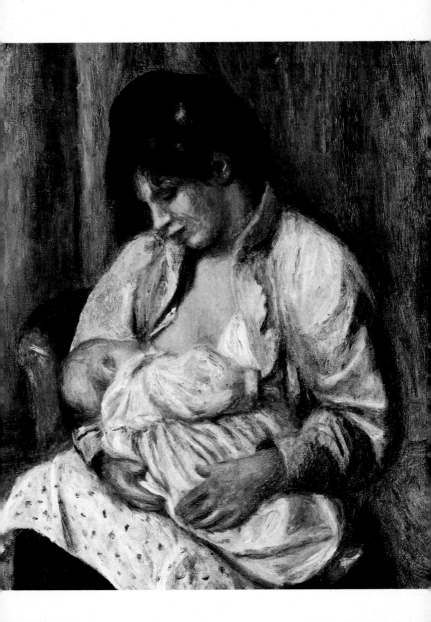

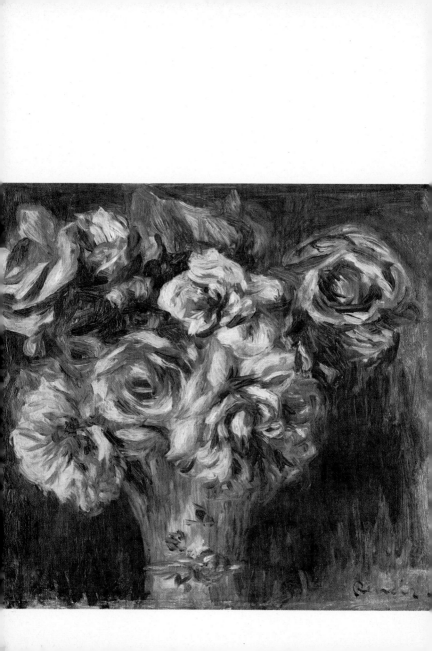

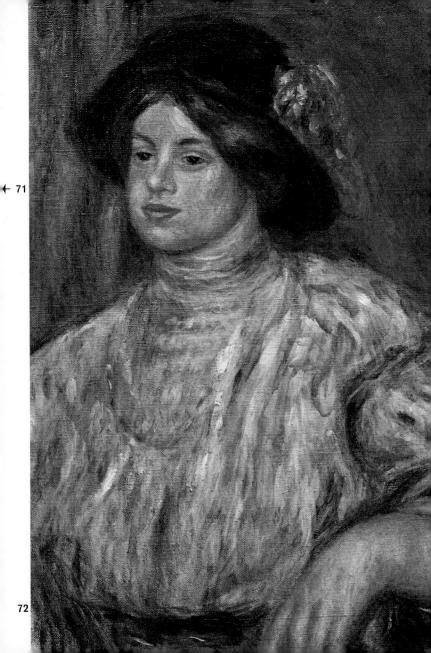

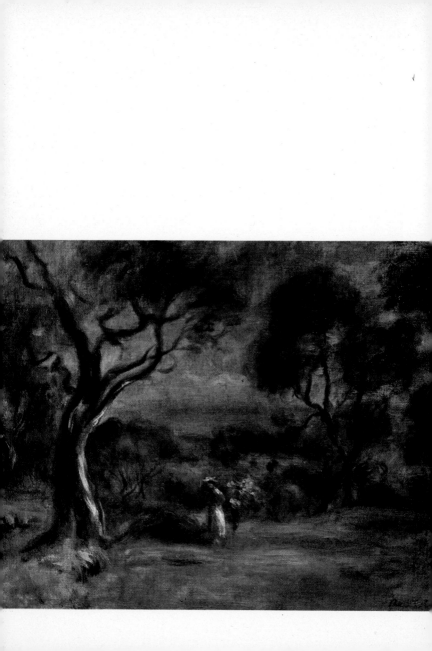

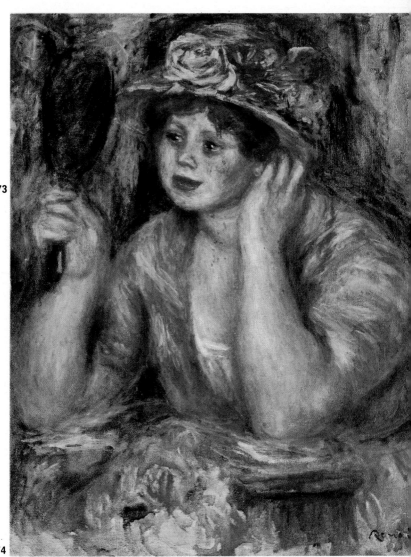

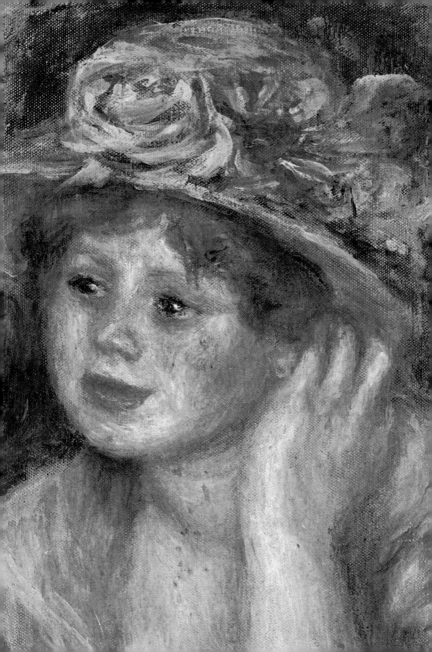

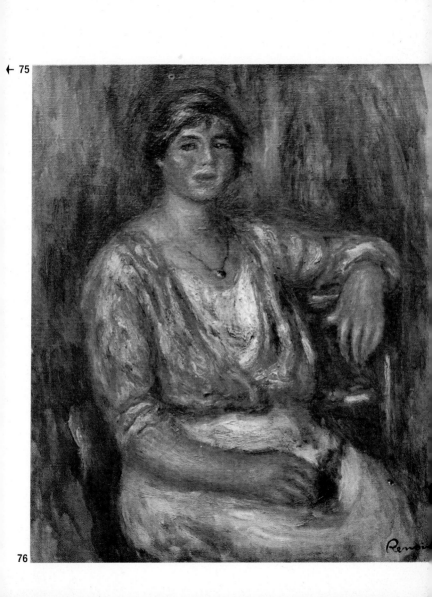

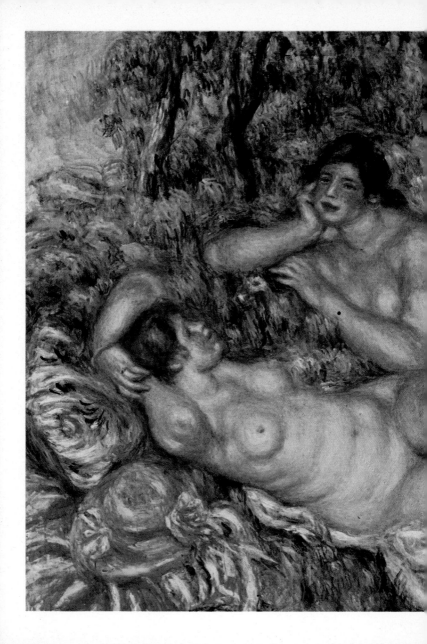

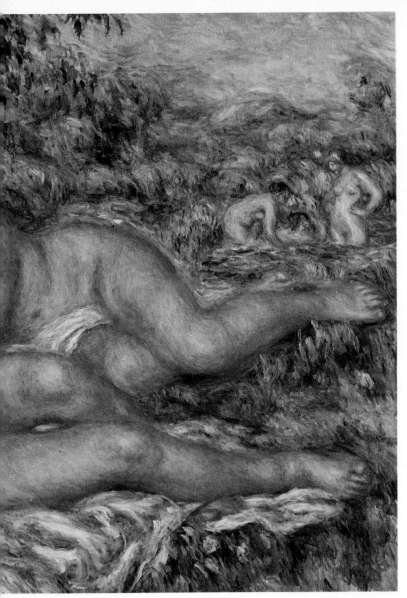